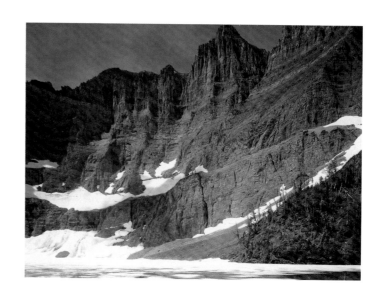

MONTANA

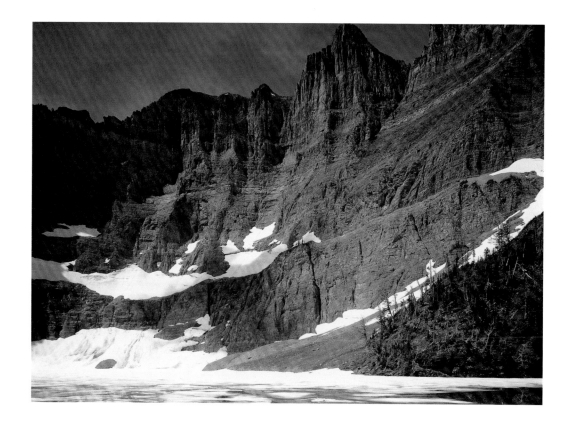

WHITECAP BOOKS
VANCOUVER / TORONTO

The information in this book is true and complete to the best of our knowledge. All
recommendations are made without guarantee on the part of the author or Whitecap
Books Ltd. The author and publisher disclaim any liability in connection with the use
of this information. For additional information please contact Whitecap Books Ltd.,
351 Lynn Avenue, North Vancouver, BC V7J 2C4.

Text by Tanya Lloyd
Edited by Elaine Jones
Photo editing by Tanya Lloyd
Proofread by Lisa Collins
Cover and interior layout by Roberta Batchelor

Printed and bound in Canada

National Library of Canada Cataloguing in Publication Data

Lloyd, Tanya, 1973–

　　Montana

　　(America series)
　　ISBN 1-55285-254-7

　　1. Montana—Pictorial works. I. Title. II. Series: Lloyd, Tanya, 1973- America series.
F732.L56 2001　　　978.6'034'0222　　　C2001-910980-6

The publisher acknowledges the support of the Canada Council and the Cultural
Services Branch of the Government of British Columbia in making this publication
possible. We acknowledge the financial support of the Government of Canada through
the Book Publishing Industry Development Program for our publishing activities.

For more information on the America Series and other Whitecap Books
titles, please visit our web site at www.whitecap.ca.

The peaks of the Continental Divide rise in stark splendor, cutting through the state of Montana in row upon jagged row. Their icy caps, the sun rising above them, grace the state seal. Their forested slopes have drawn mountaineers, prospectors, hunters, and miners since Lewis and Clark first crossed the continent, and their valleys have birthed the legends of the Wild West. This is the land that natives once called "the backbone of the world" and it divides the continent neatly in two. The Columbia River tumbles down the hillsides to the west, on its route to the Pacific, and the Missouri River winds east toward the Mississippi.

In the 1860s, this wilderness, only partially explored and traditionally home to native hunters and traders, captured the world's attention. Prospectors struck gold on Grasshopper Creek in 1862, and a year later six prospectors stumbled upon the mother lode at Alder Gulch — the world's richest placer gold deposit. Soon, the population of Virginia City swelled to 10,000. Prospectors poured into the region, followed closely by entrepreneurs, agents, and entertainers.

Montana's gold strikes followed the predictable pattern of boom and bust. Yet today, more thrill-seekers than ever are lured to the state by a different kind of bonanza. From the alpine meadows of Glacier National Park and the woods of Yellowstone, to the shores of Flathead Lake and the badlands of the east, visitors enjoy the riches of pristine mountain parks and picturesque rangelands. The state (America's fourth largest) is home to less than a million people, but Glacier National Park alone attracts more than 1.6 million visitors each year.

In every region, there's much more to experience than panoramic views. Whitewater rafting, kayaking, hiking, fishing, hunting, camping, mountain biking, and hang gliding all draw their fair share of enthusiasts. Historic sites allow glimpses of Montana at the time of Lewis and Clark, and parks preserve evidence of the dinosaurs that roamed here 80 million years ago. Local communities host a constant string of events, ranging from Livingston's Rodeo Days to the annual Running of the Sheep in Reedpoint. For today's adventure-seekers, Montana more than lives up to its reputation as the Treasure State.

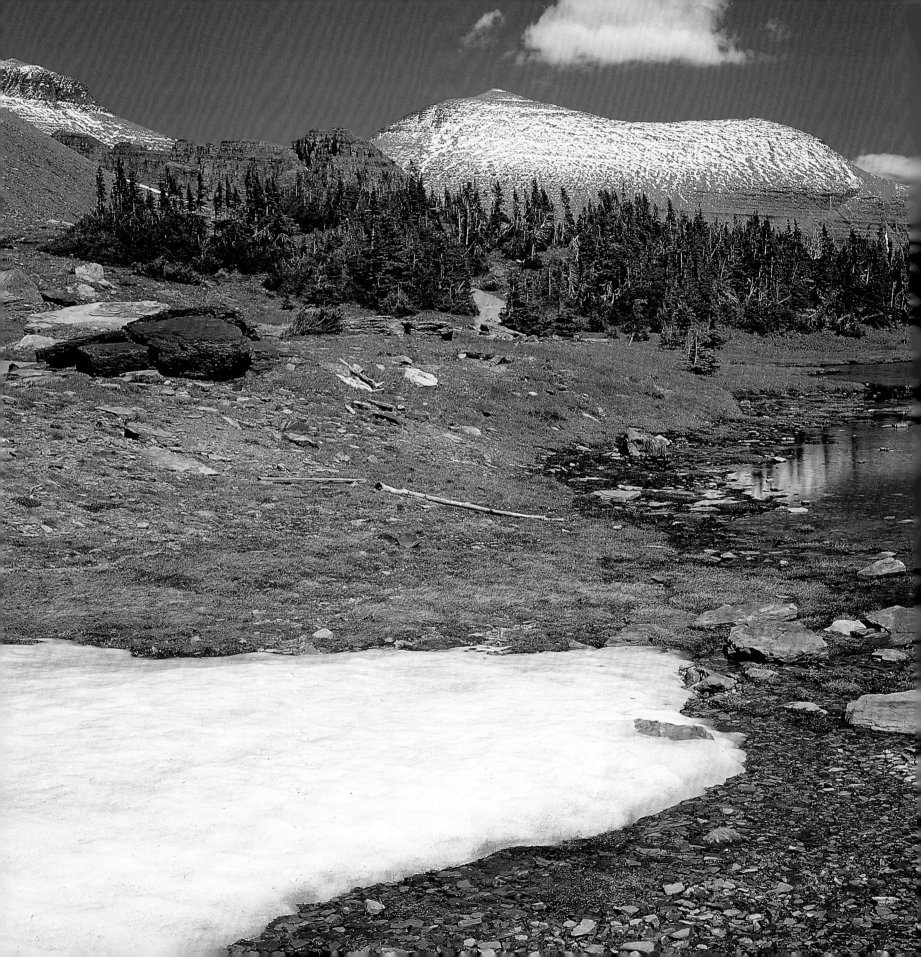

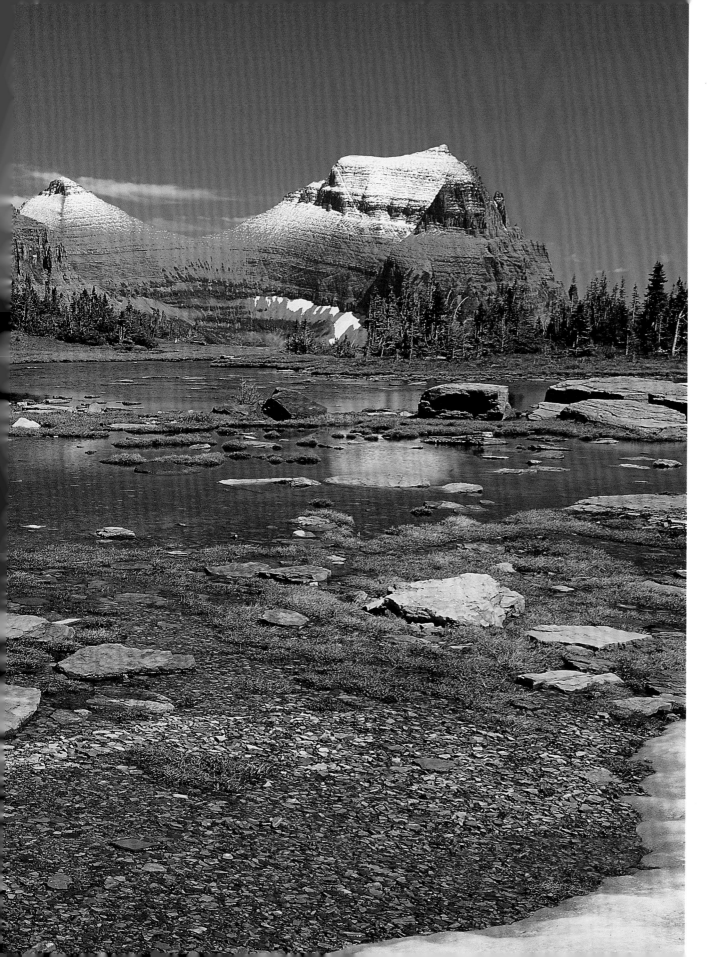

Encompassing more than a million acres, Glacier National Park in northern Montana includes rugged peaks, crystal lakes in alpine bowls, and enormous mounds of rock and debris — all the result of the glaciers that carved out this region.

When the majesty of the mountains began to draw visitors in the late 1800s, local residents pressured the government to preserve the land. George Bird Grinnell, one of the first Europeans to explore the slopes, lobbied to have the region named a forest preserve, then a national park in 1910.

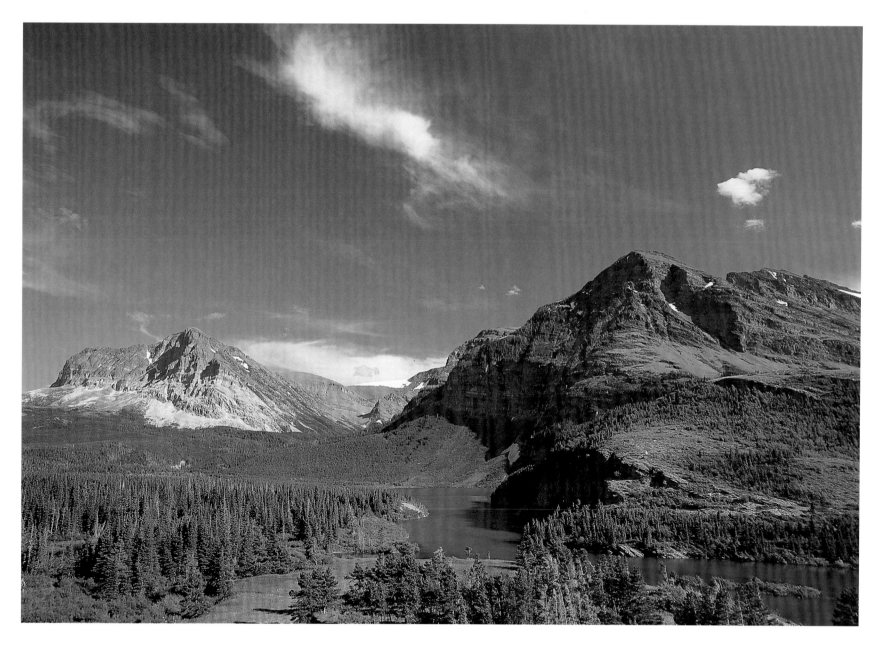

More than 50 glaciers adorn the summits of Glacier
National Park, their meltwater feeding over 250 lakes.

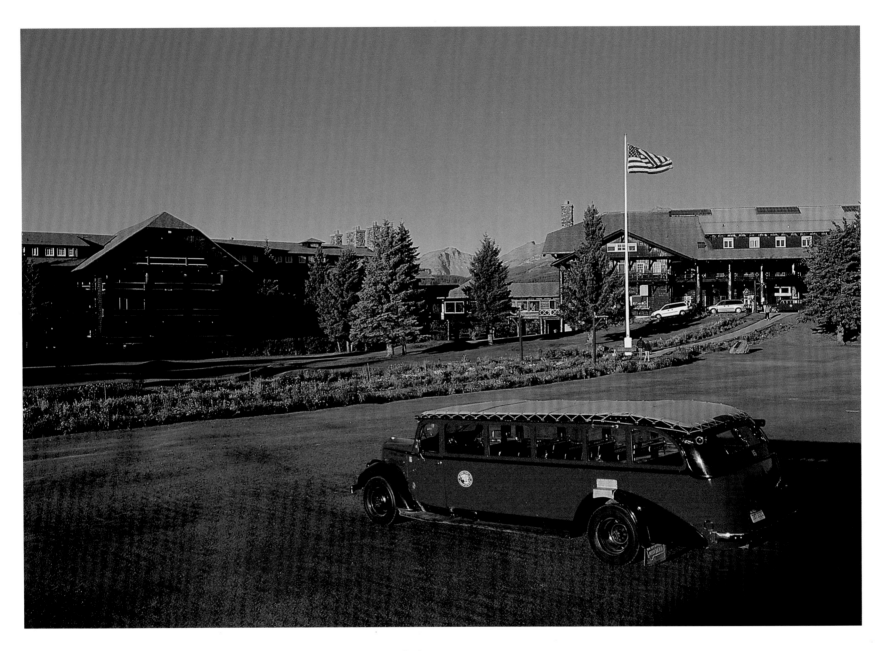

Visitors to Glacier Park Lodge find themselves amid the same scenery as in 1913, when the Great Northern Railway opened its newest accommodations. The lodge is built of massive Douglas fir beams cut from 500- to 800-year-old trees.

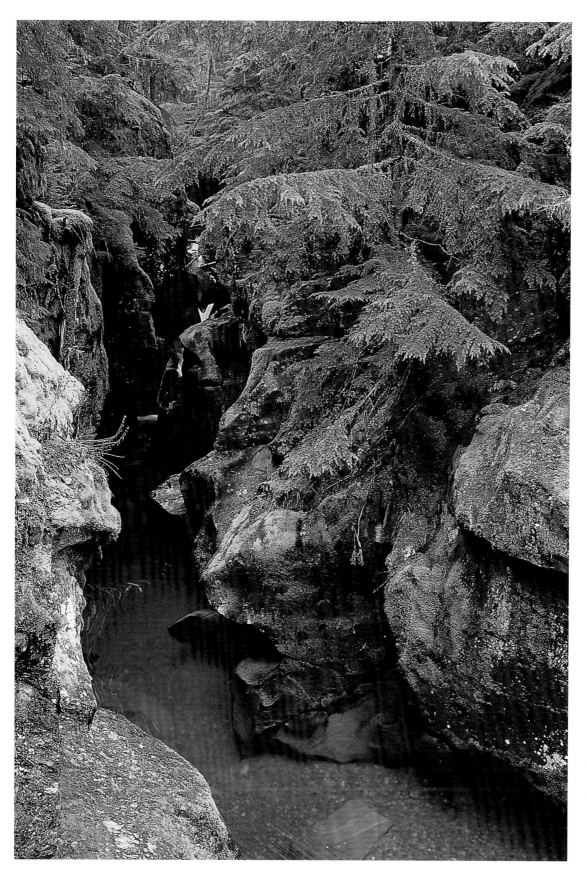

There are more than 700 miles of hiking trails in the wilderness of Glacier National Park. Some, such as the Avalanche Lake route across the gorge, are easy afternoon walks; others lead experienced hikers on multi-day excursions.

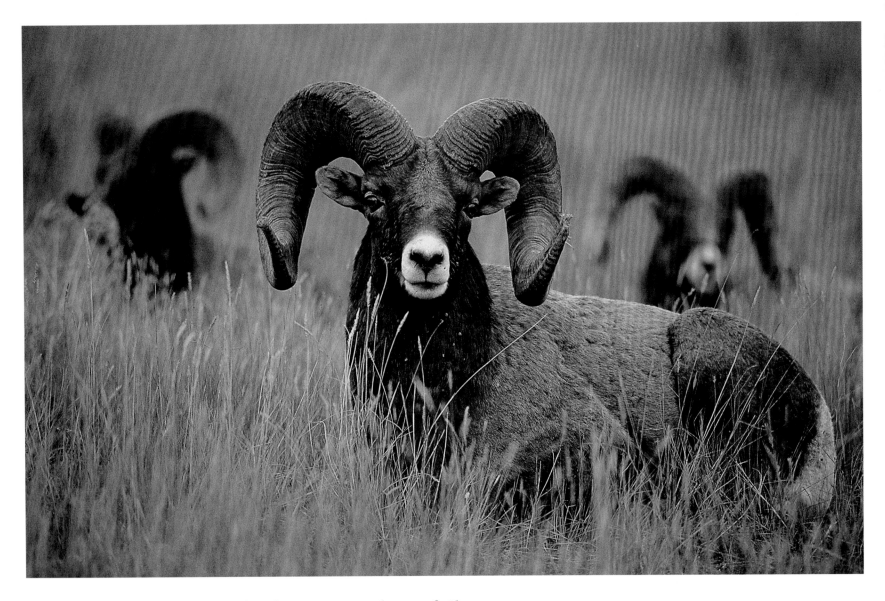

Reclusive bighorn sheep inhabit the mountain slopes of Glacier National Park, along with bears, wildcats, caribou, ospreys, and bald eagles. In spring and summer, more than 1,000 wildflower species bloom in the valleys.

In 1931, Rotary Clubs in Alberta and Montana suggested the creation of an international preserve combining Glacier National Park with a Canadian park just across the border. A year later, Waterton-Glacier International Peace Park was established, and later named a World Heritage Site.

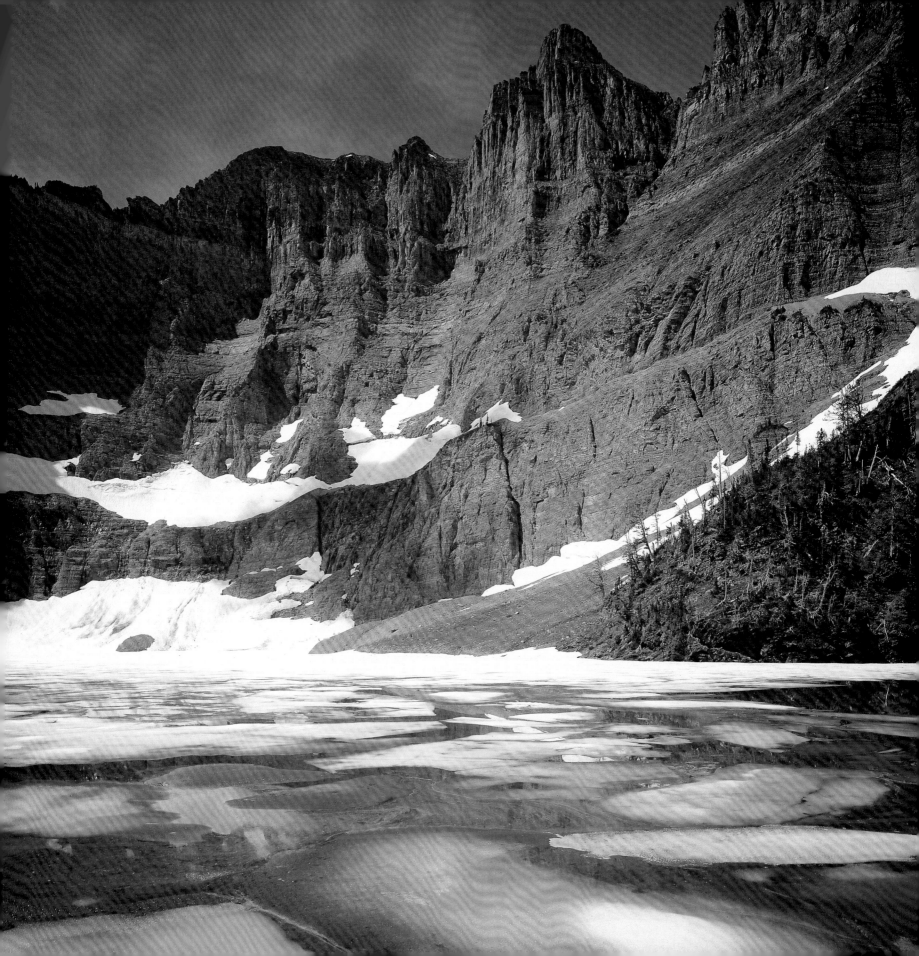

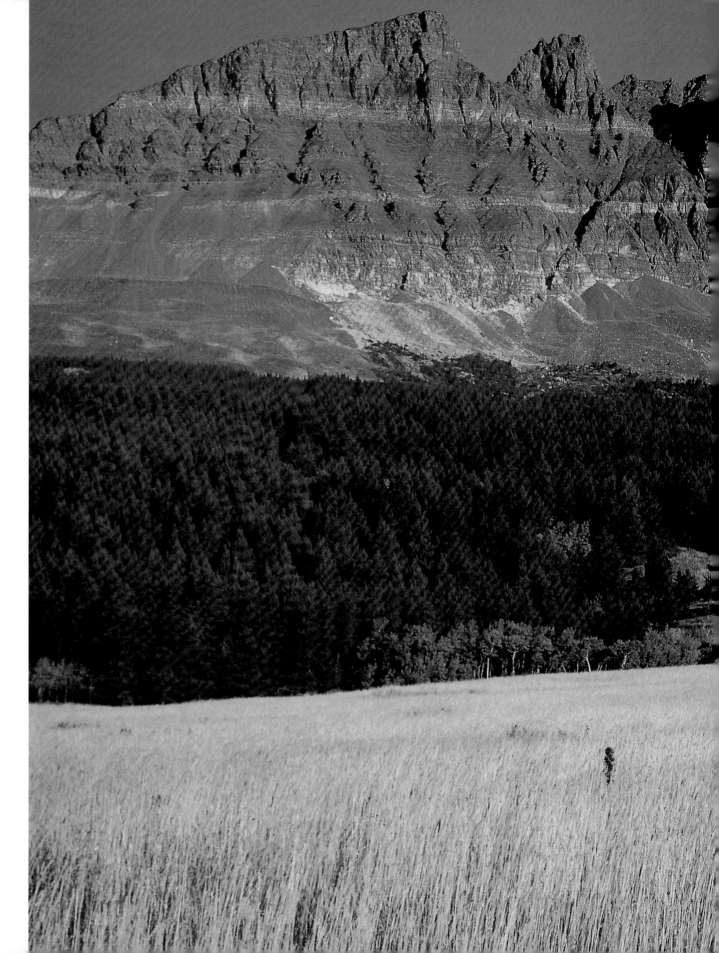

The native grasses
of Two Dog Flats
are habitat for small
mammals, prey for
the hawks that often
circle above. This is
one of many scenic
stops along Going-
to-the-Sun Road, a
winding, treacherous
route across Glacier
National Park.

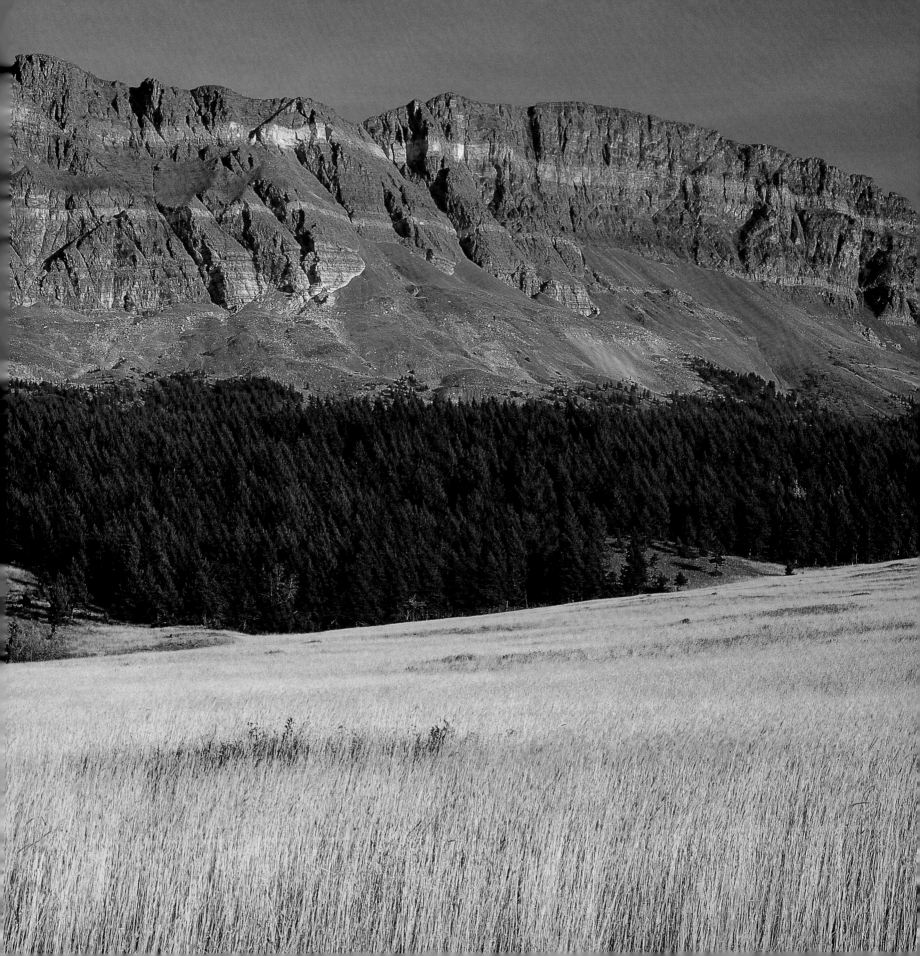

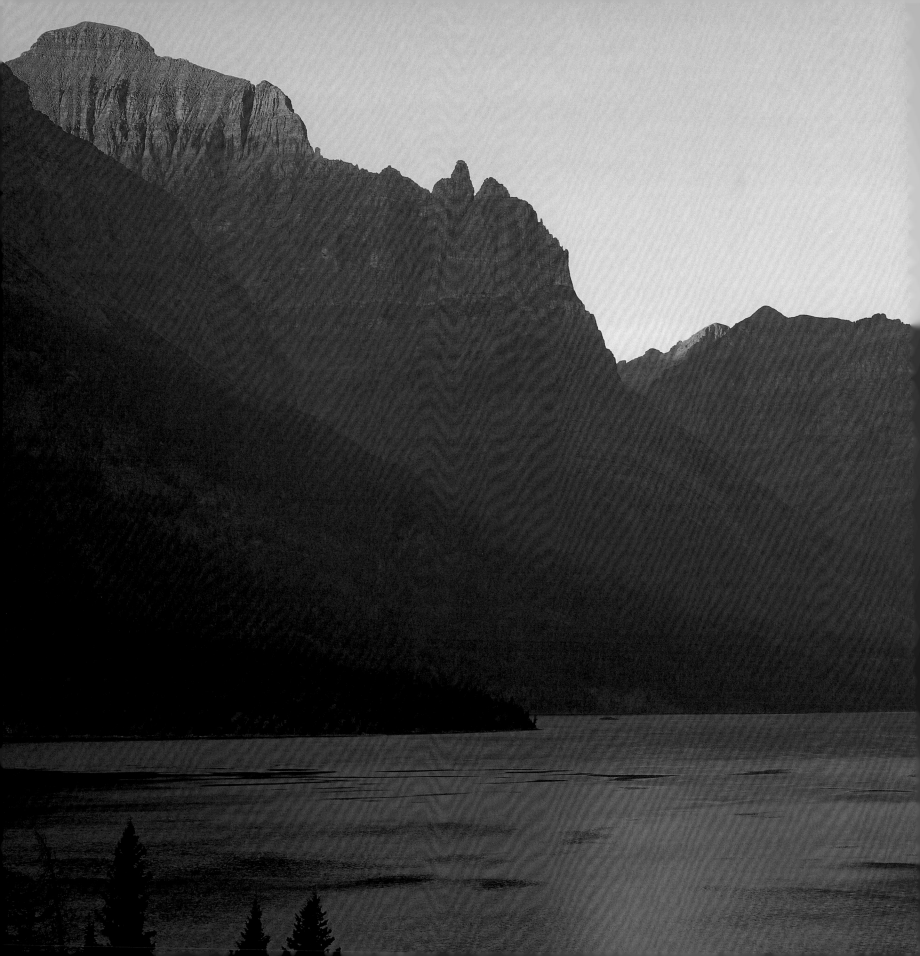

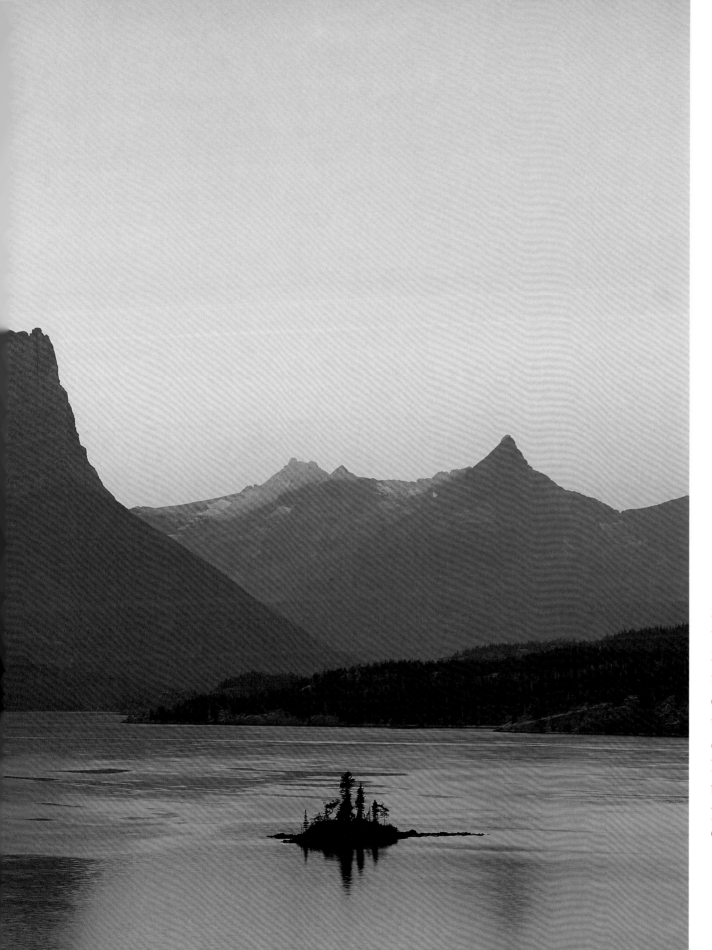

Sunrise highlights the peaks above Saint Mary Lake, a thin half-moon of emerald water on the eastern edge of Glacier National Park. This is one of the preserve's most popular hiking destinations.

17

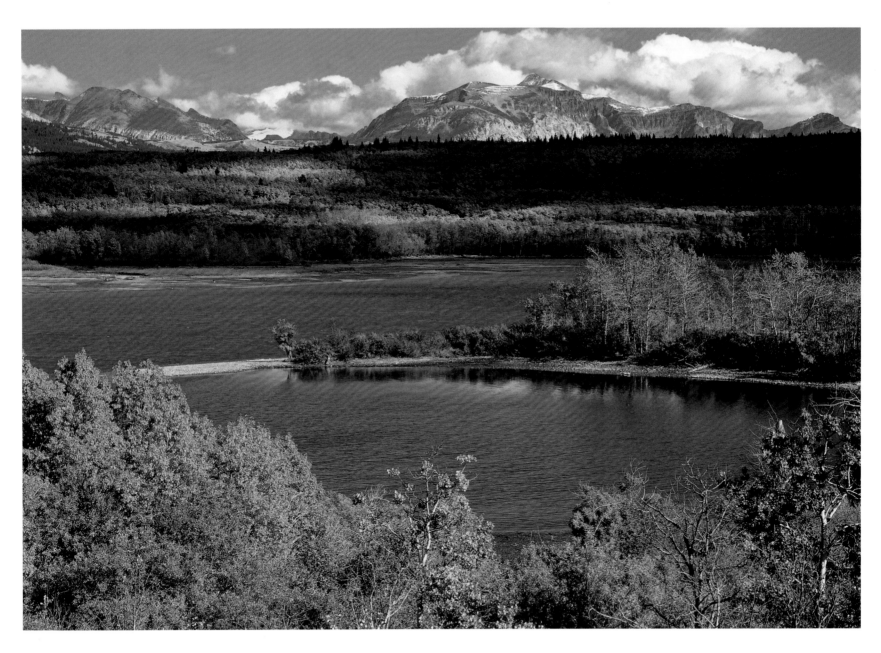

The Blackfeet Nation once ruled the plains east of the Rocky Mountains, their territory stretching into the foothills and north into present-day Alberta. Today, the Blackfeet Reservation includes 1.5 million acres in northern Montana and is home to about 7,000 people.

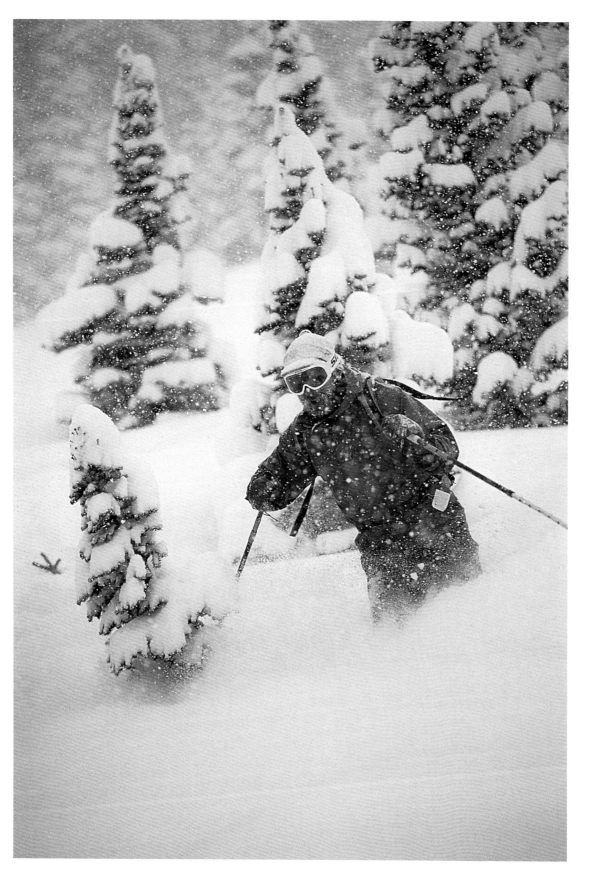

Big Mountain in Whitefish is named for its 2,500 vertical feet of powder. With 3,000 acres and more than 80 runs, the ski resort is one of the most popular in North America.

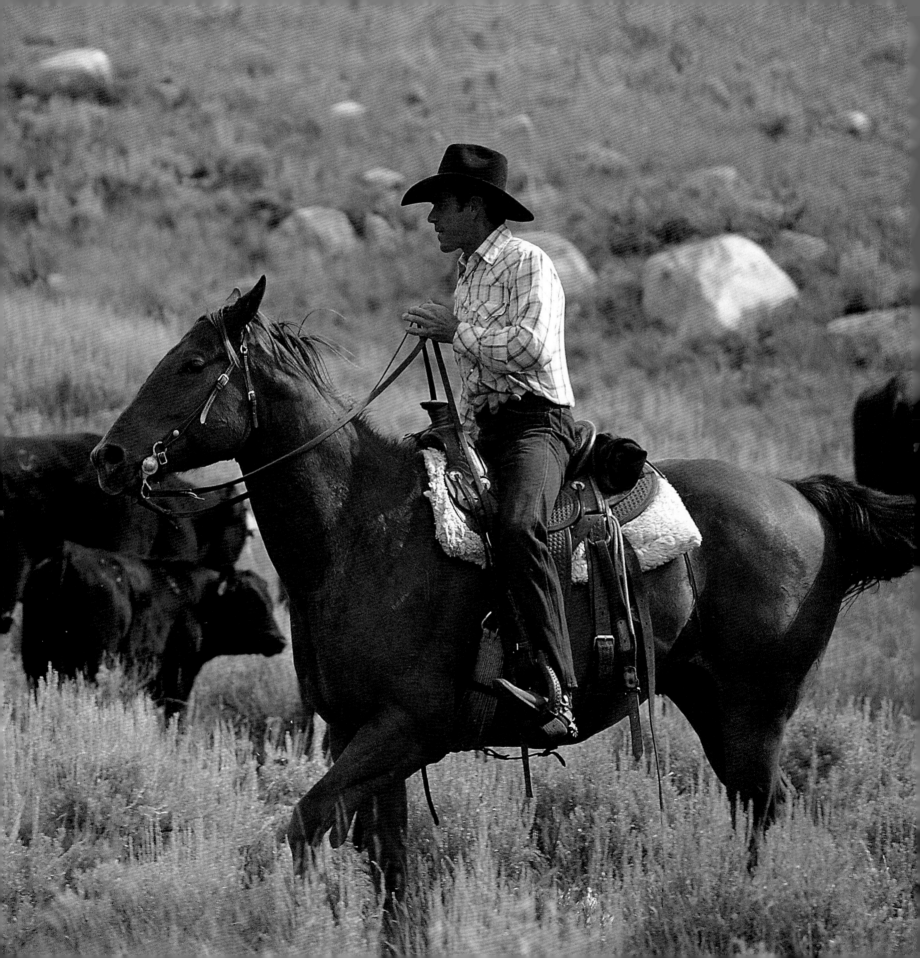

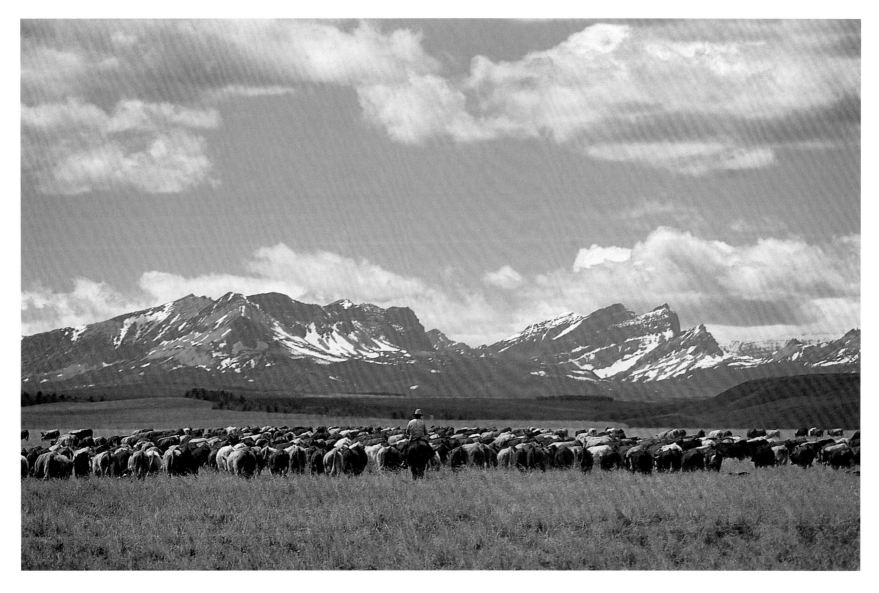

Driving the cattle herds from the sheltered valleys to the abundant summer grasses of the mountain meadows has been a tradition in central Montana since the first ranchers arrived here in the mid-1800s.

Visitors join in many cattle drives, paired with a wrangler. A day of riding is often followed by an open-air barbecue and tents pitched under the prairie stars.

A shop in the Flathead Valley sells antique collectibles to tourists. Tucked in Montana's northwest corner, the valley is a haven for cross-country skiers, snowmobilers, hikers, and anglers.

FACING PAGE –
The murals of Brother Joseph Carignano draw visitors to the St. Ignatius Mission on the Flathead Reservation. Carignano, a cook at the mission with no previous art training, created 58 murals throughout the church.

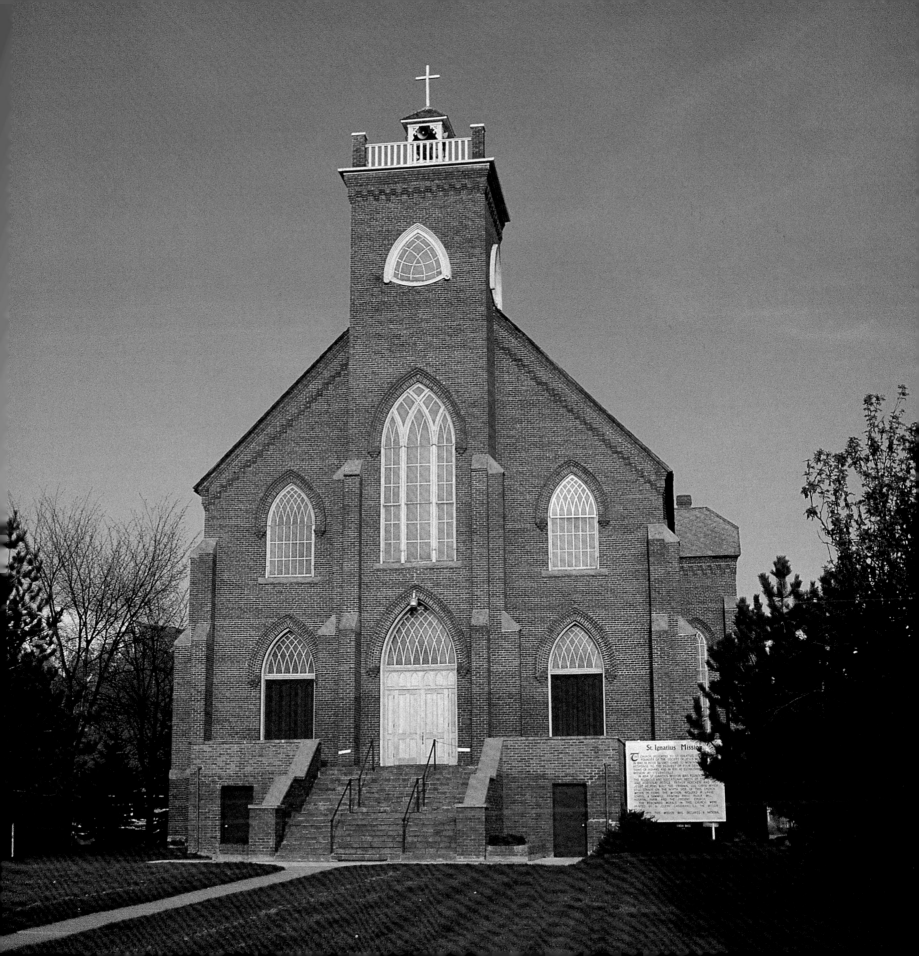

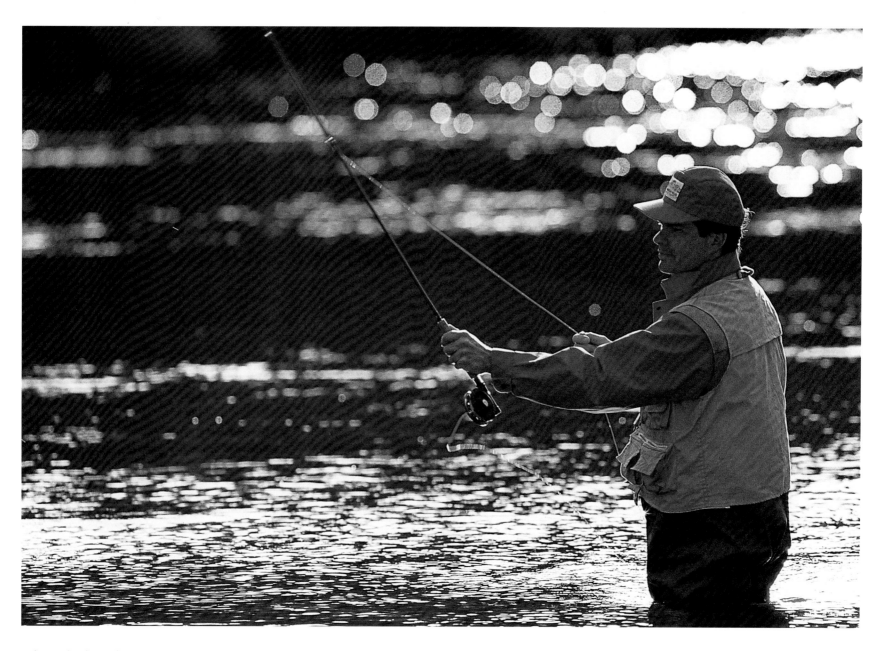

The Flathead River's South Fork is a favorite with fly fishers, who travel from across the continent to test the wiles of rainbow, brown, brook, and bull trout. Many lodges in the area cater specifically to anglers.

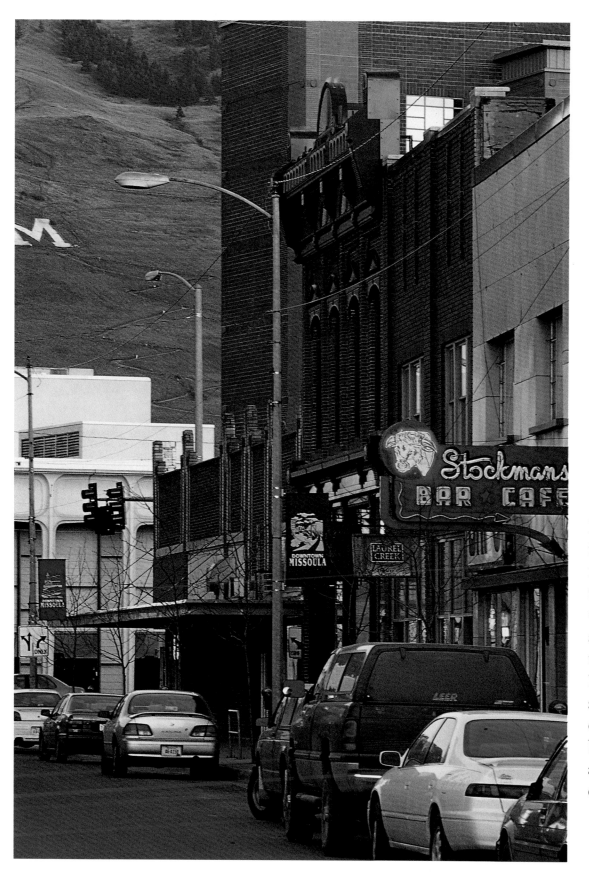

Missoula was born in 1865, when a flour mill opened at the confluence of the Clark Fork, Bitterroot, and Big Blackfoot rivers. Today, many Missoula residents spend much time outdoors — mountain biking, hang gliding, and whitewater rafting opportunities beckon.

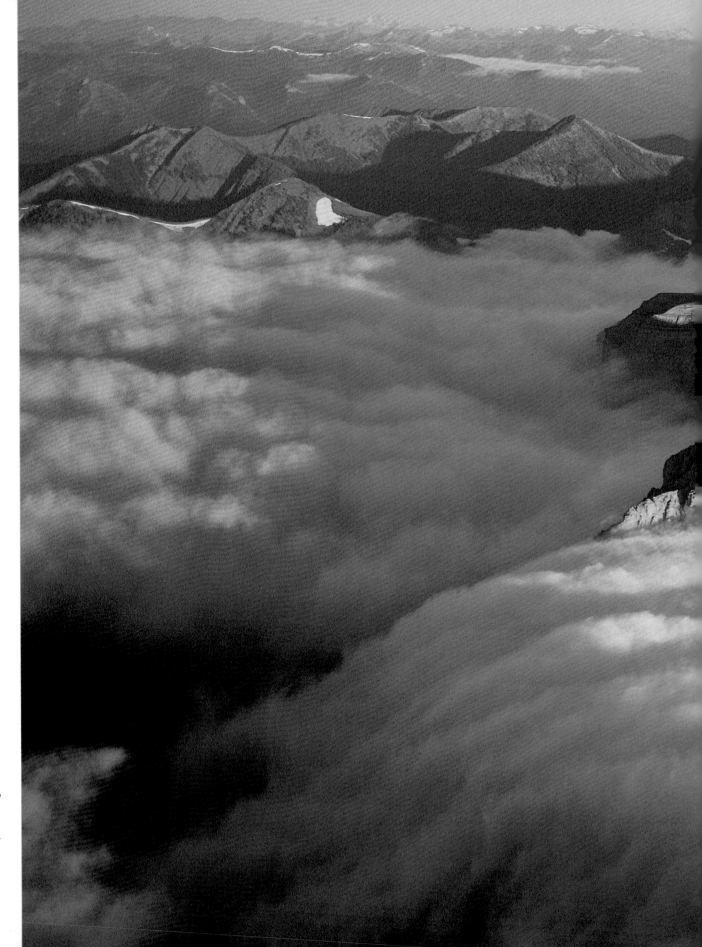

Where they slice through the million-acre Bob Marshall Wilderness, the peaks of the Continental Divide reach an awe-inspiring 9,000 feet. Wolverines, moose, elk, and grizzlies inhabit the wilderness valleys.

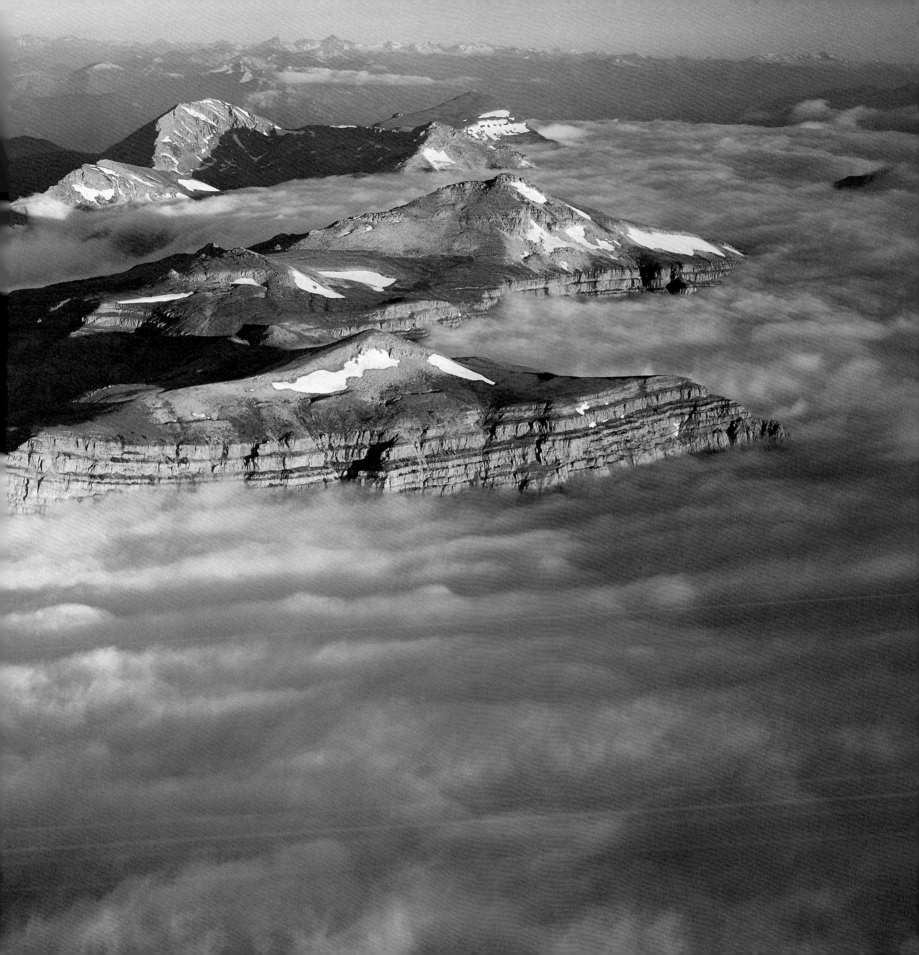

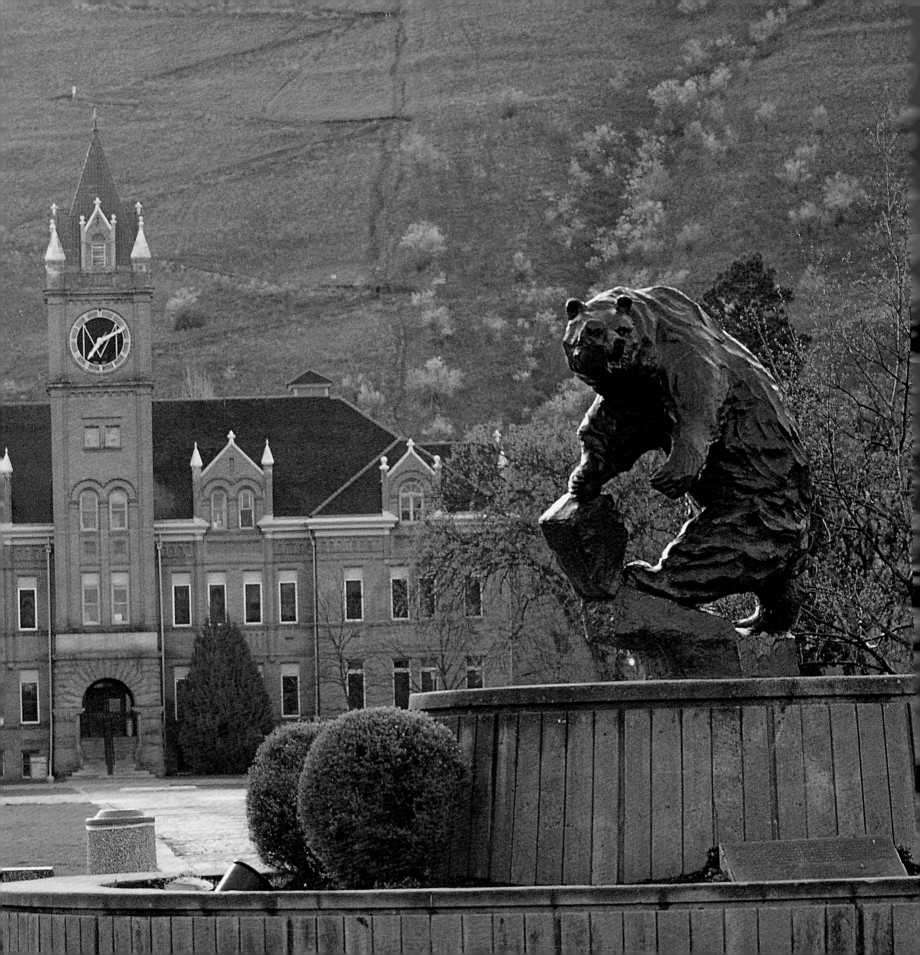

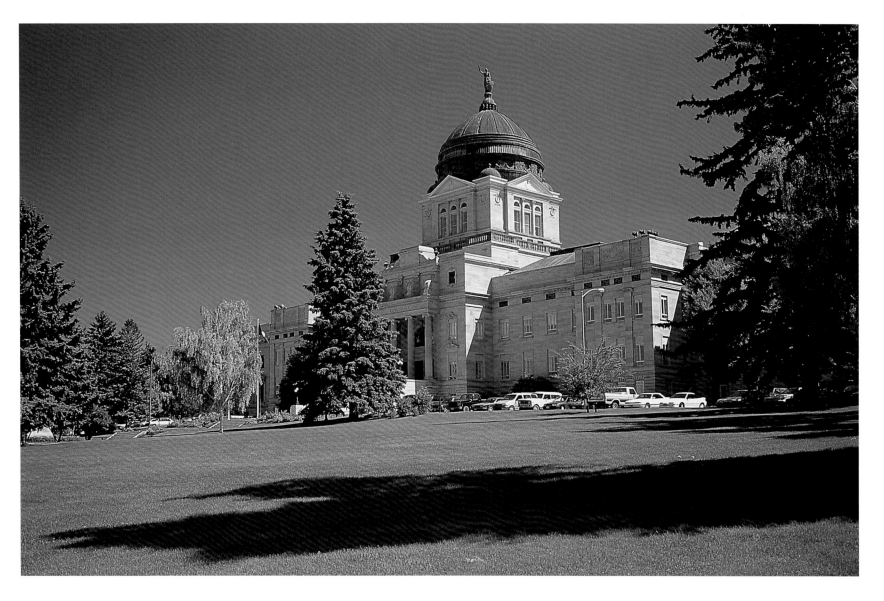

Architects Charles Bell and John Kent designed the State Capitol in Helena. The Greek-style sandstone building topped with an elegant copper dome was completed in 1902.

Rudy Autio's *Grizzly* statue was completed in 1968, on behalf of the University of Montana alumni. The sculpture stands at the end of Ryman Memorial Mall on the university campus in Missoula.

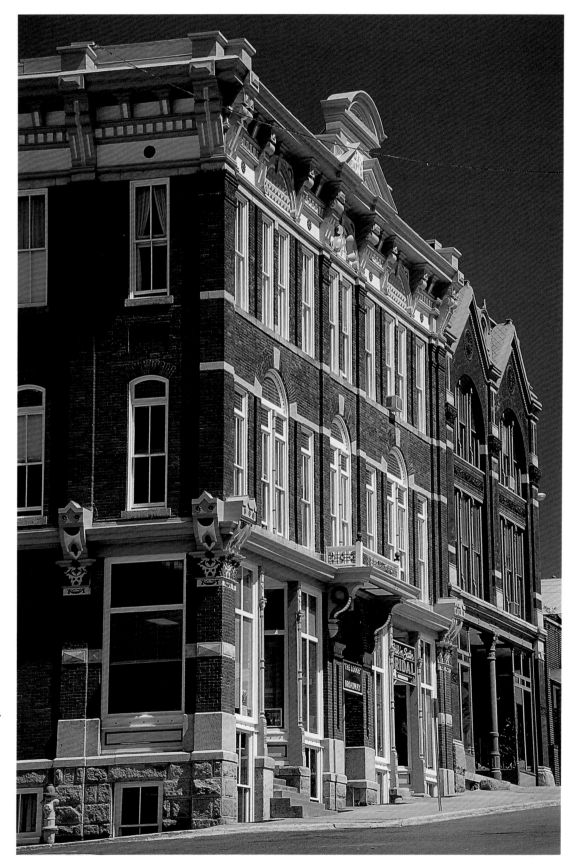

Helena boomed in 1864 when four prospectors discovered gold in nearby Last Chance Creek. The rush was short-lived but the town remained as a supply depot and commercial center for settlers and prospectors. Helena became Montana's capital in 1875.

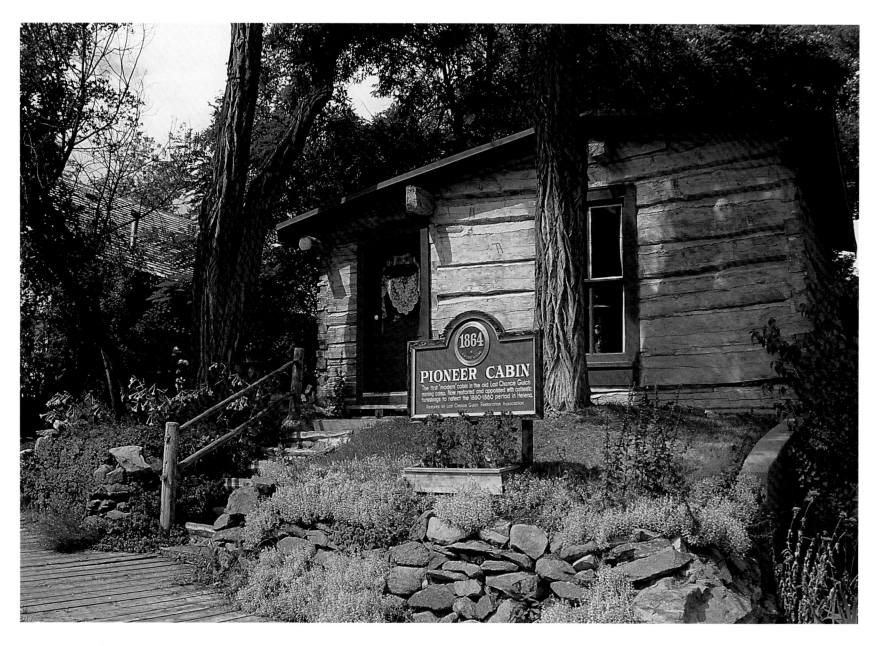

Built in 1864, this pioneer cabin in Helena boasted two signs of luxury — a wooden floor, rather than the traditional packed dirt, and a glass window at the front.

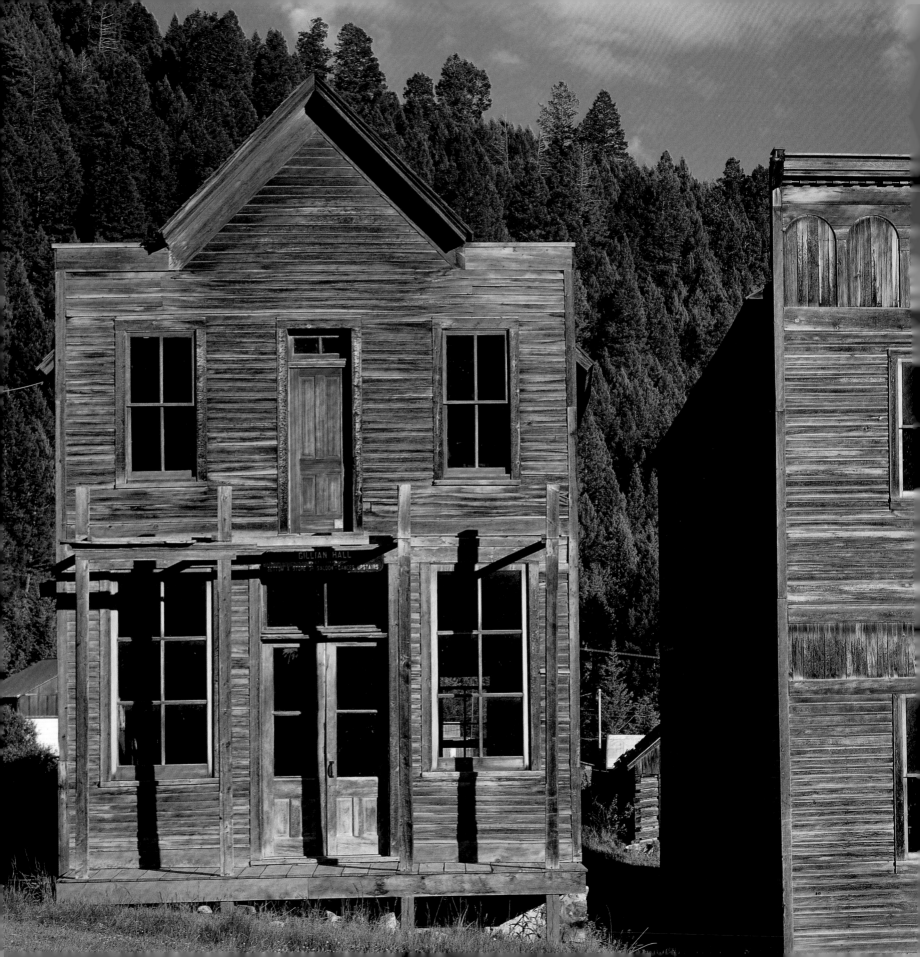

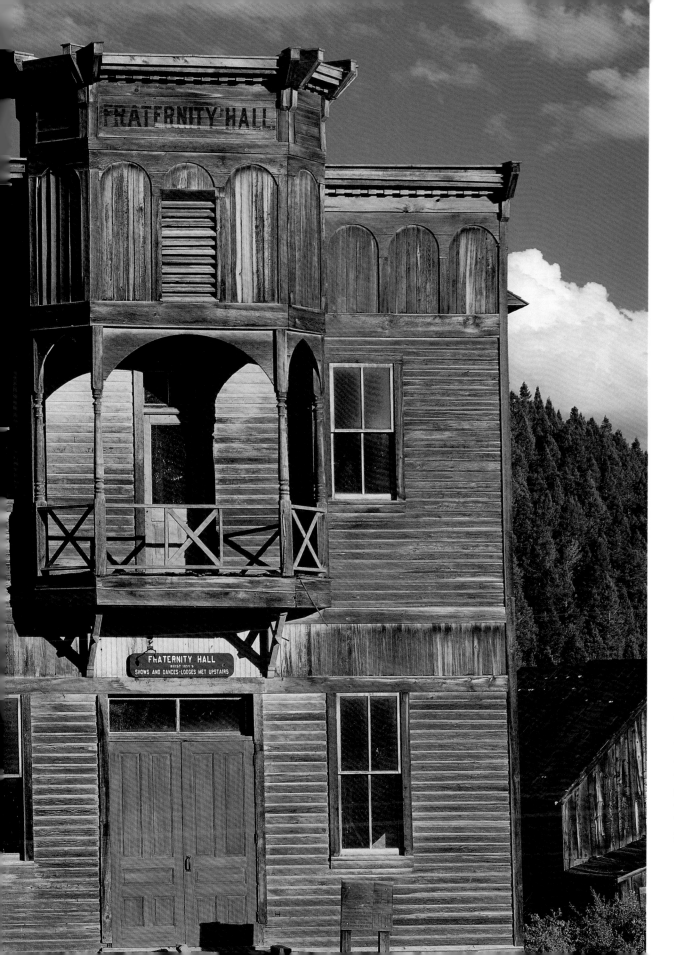

Business baron Anton M. Holter founded the Elkhorn Mining Company in 1875, and plumbed the land's silver veins with such success that he sold his company for half a million dollars in 1889.

33

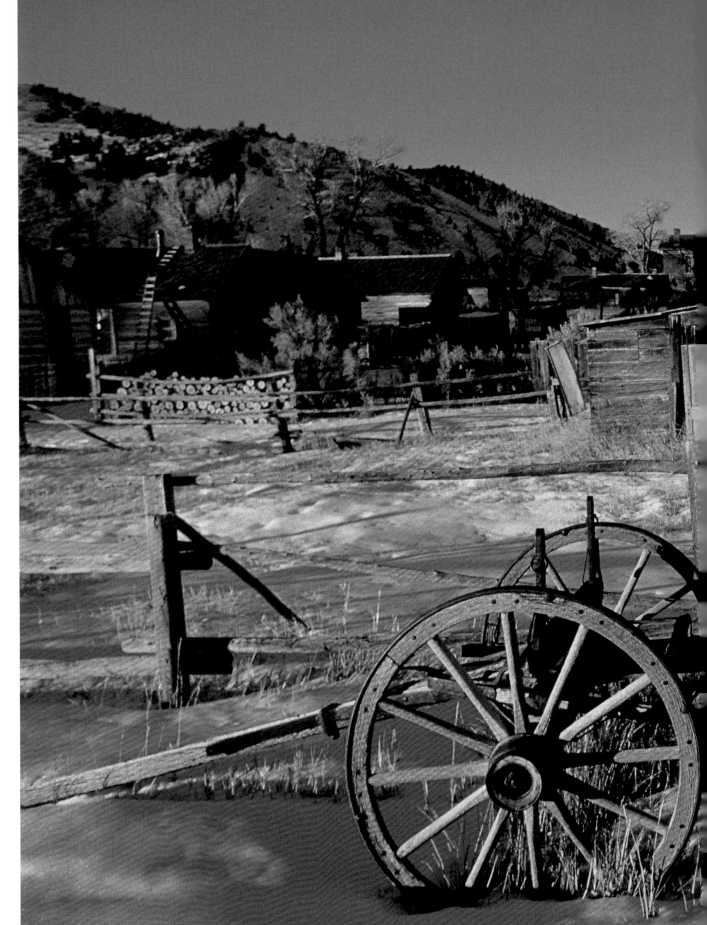

The mines at Elkhorn eventually collapsed not because of a lack of silver, but because of a dramatic decrease in demand. The boom was over by 1897.

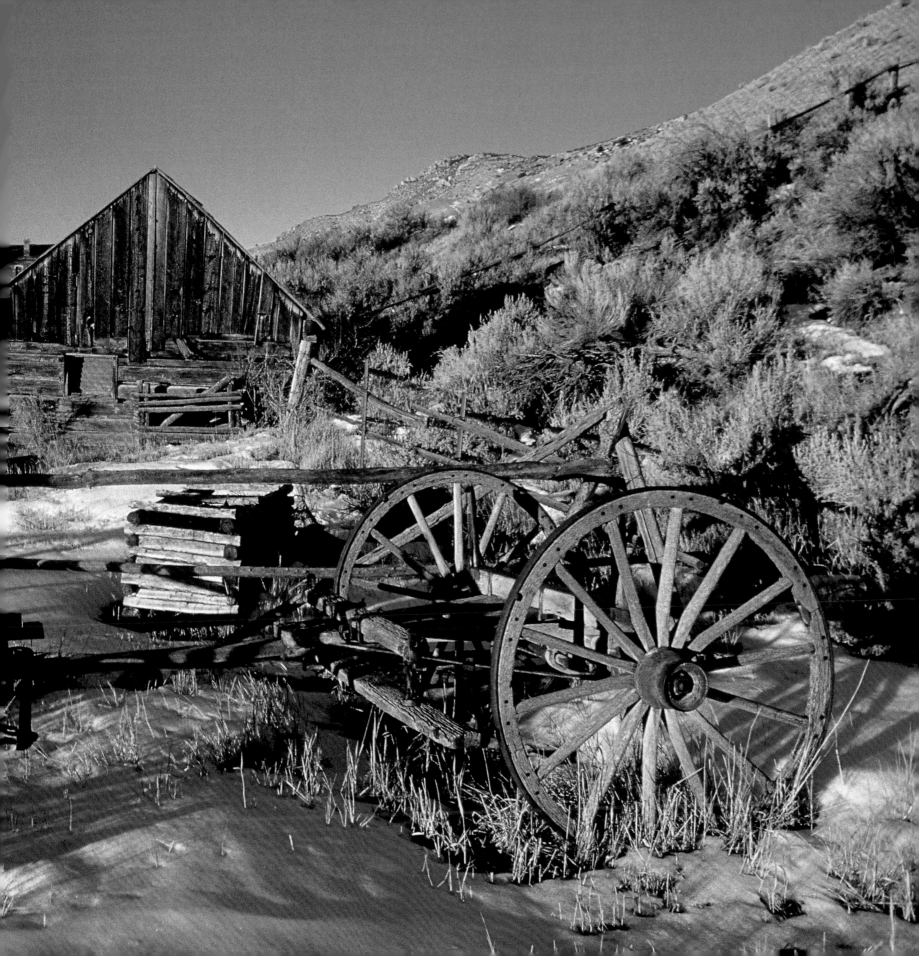

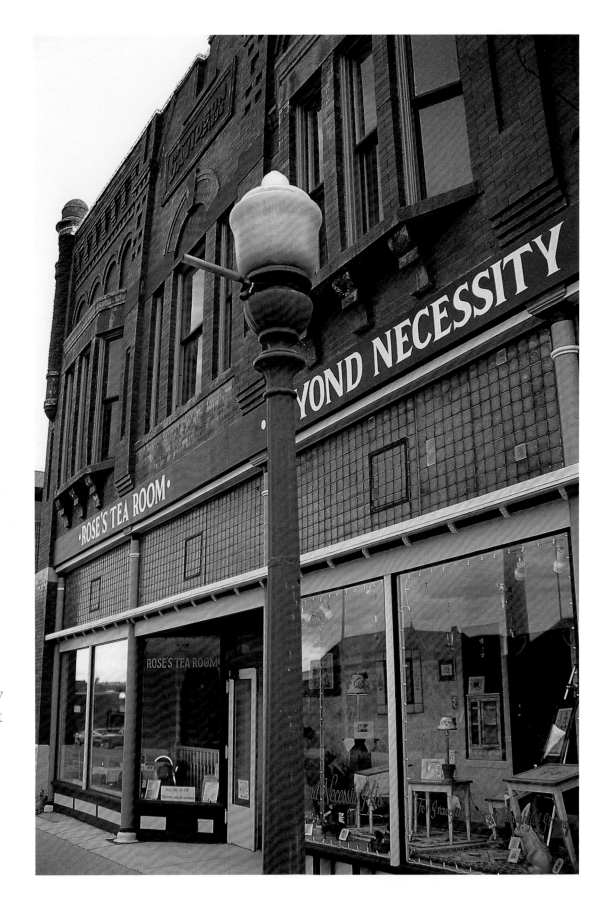

Anaconda, in the shadow of the Continental Divide, is home to about 10,000 people. Today it is a gateway to mountain recreation, but it was originally an industry town, named in 1888 for the Anaconda Copper Mining Company.

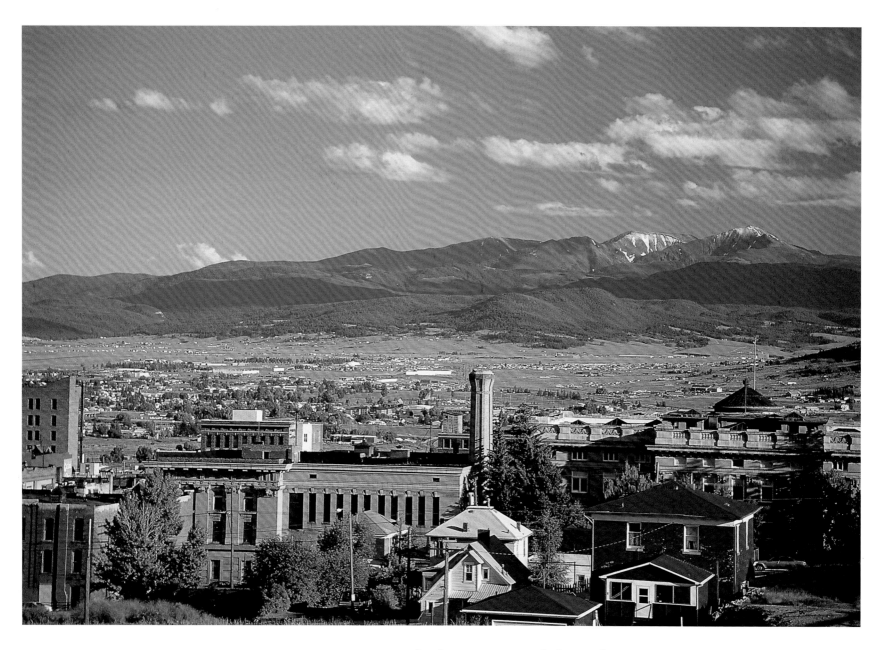

Between the late 1800s and the early 1900s, when many mines in the area closed, miners drew $22 billion of copper and other metals from the lands surrounding Butte. In the early 1900s, this was the largest city between St. Louis, Missouri, and the Pacific Ocean.

The Anselmo Mine Yard in Butte shows visitors what life was like for the underground workers in the glory days of the copper mines. Historic miners' homes line the streets nearby.

FACING PAGE –
Agriculture contributes $2.3 billion a year to Montana's economy — about twice as much as tourism, the state's second-largest industry. The most successful agricultural products include livestock, wheat, barley, and tree fruit.

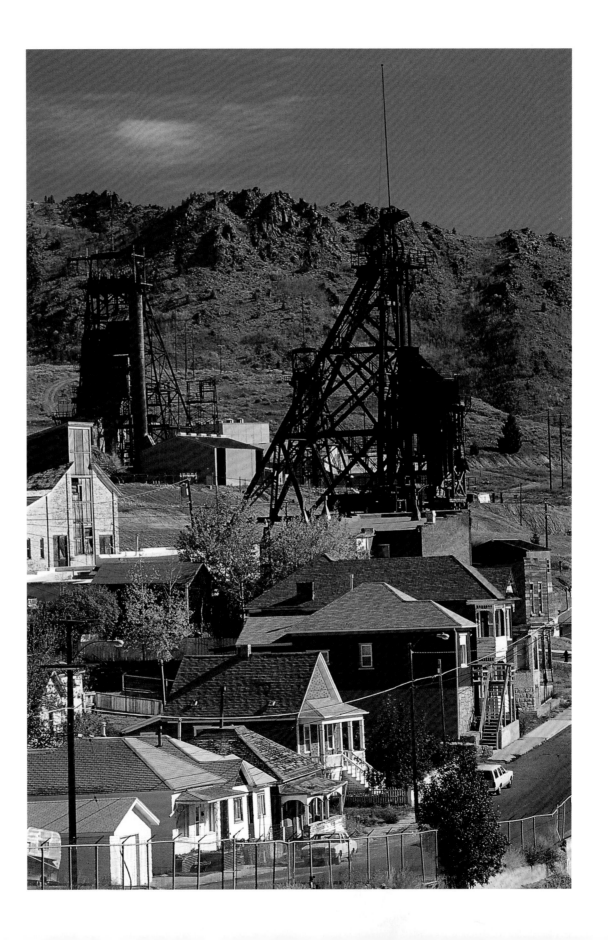

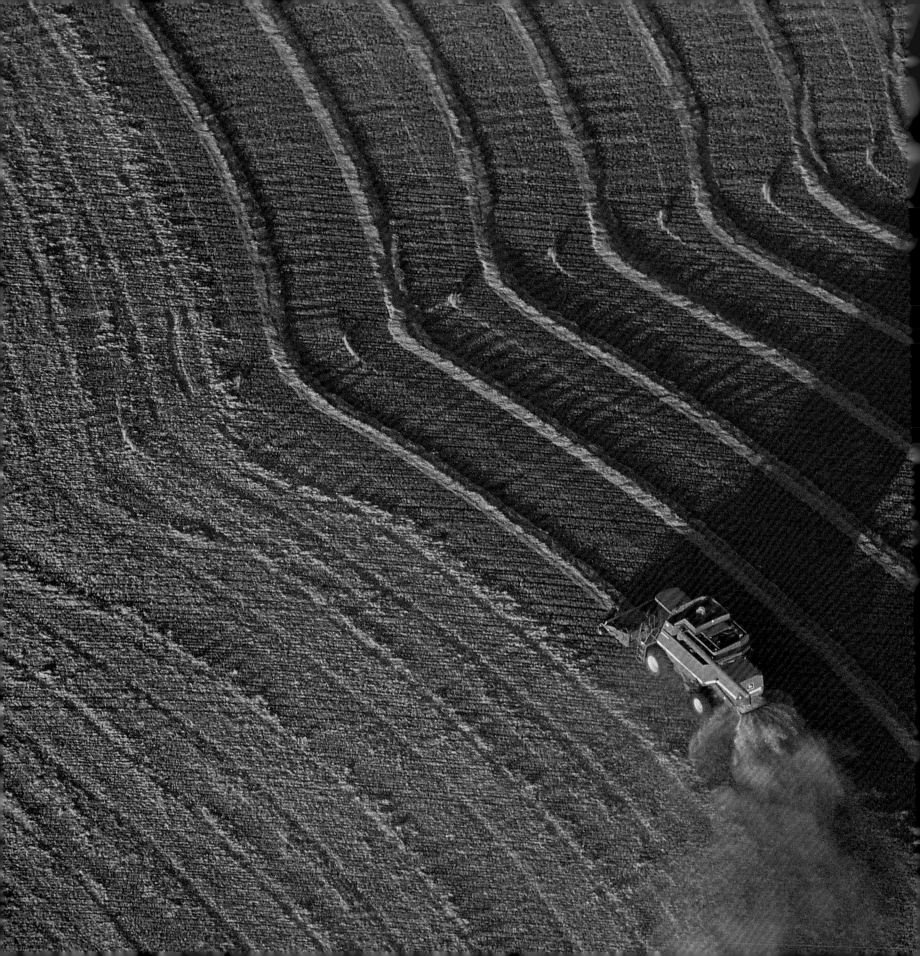

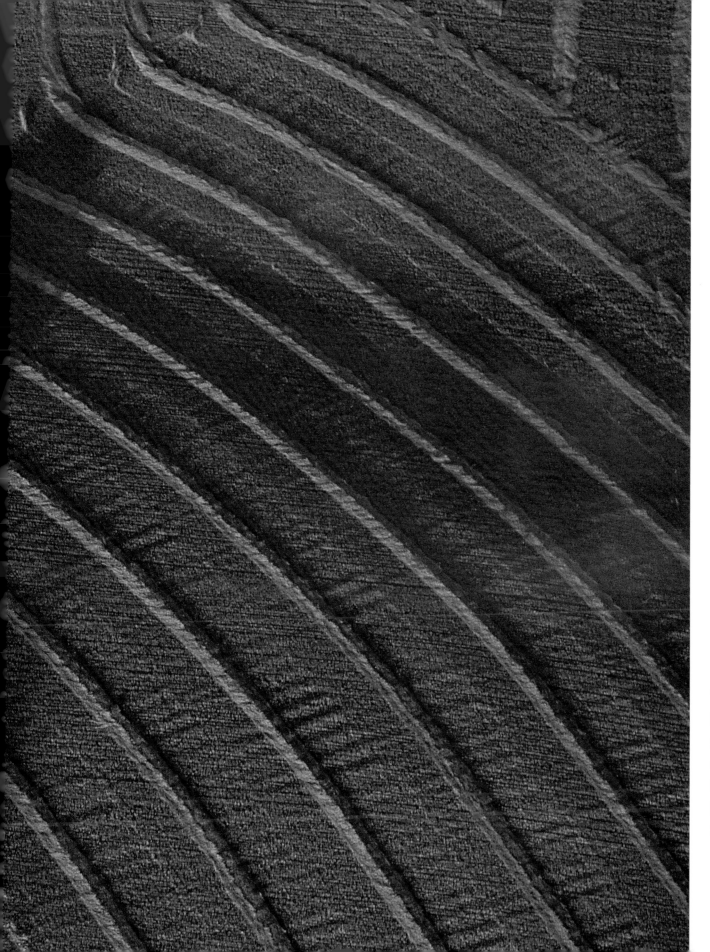

Twenty-two thousand farms encompass more than 60 percent of Montana's land. It is the second-largest farming state in the nation.

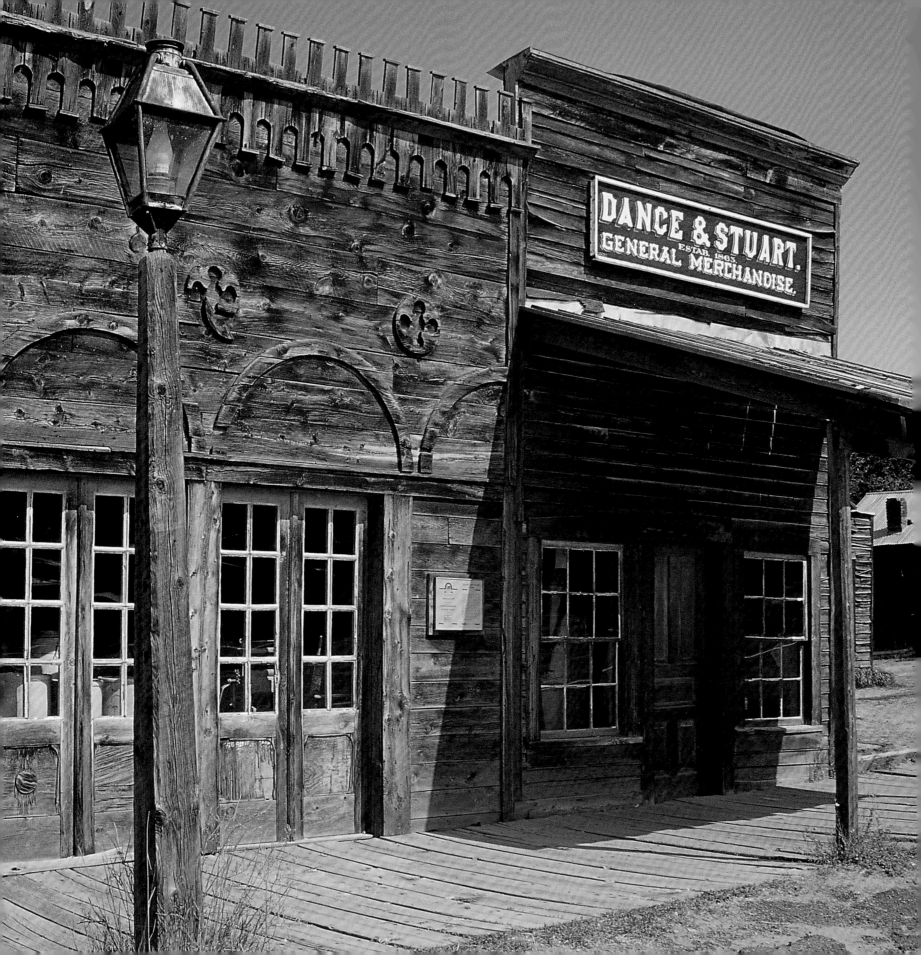

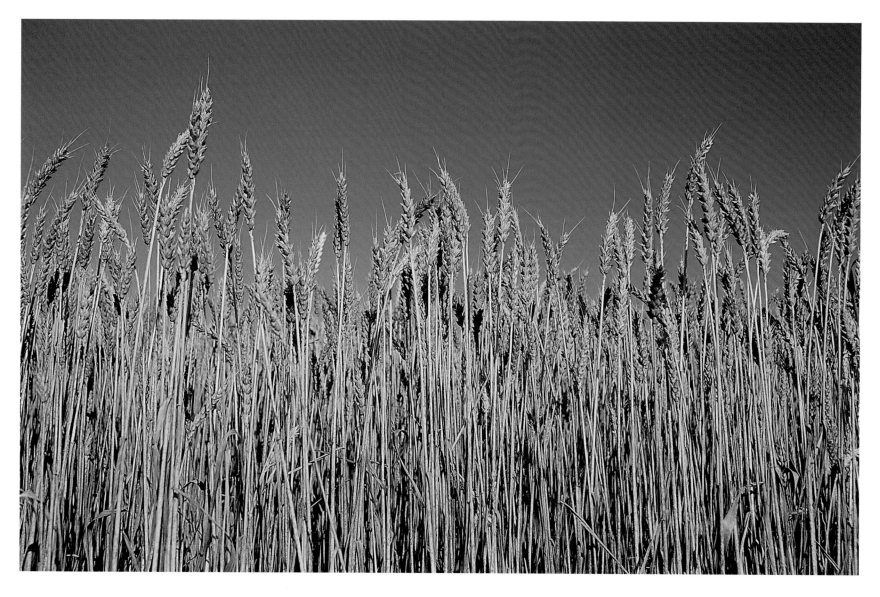

Wheat is Montana's largest crop, and the state is America's second-largest producer of spring wheat and fourth-largest producer of durum wheat. Statistically, each Montana farmer produces enough in one year to feed 129 people.

A trip to Virginia City is a journey into the old west. Inns and homes, storefronts and cafés have been restored to look as they did in the Victorian era, when this was a gold rush town.

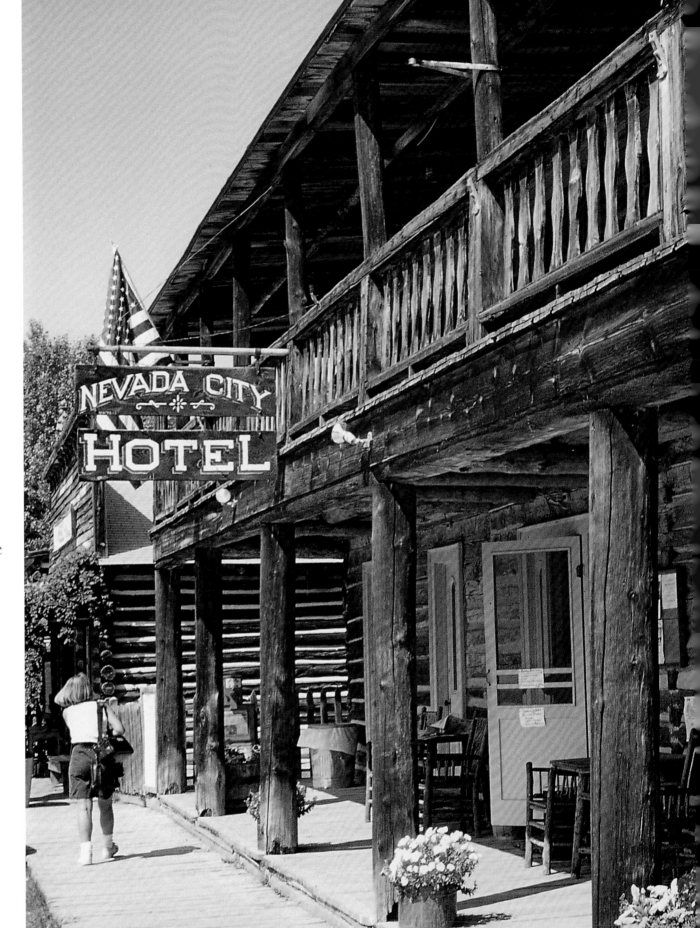

In 1874, 35,000 people lived in side-by-side Virginia City and Nevada City. Today, sightseers experience the gold rush in Nevada City, where crowds gather at the opera house, outlaws stage gunfights on the streets, and a narrow-gauge railway runs alongside the town.

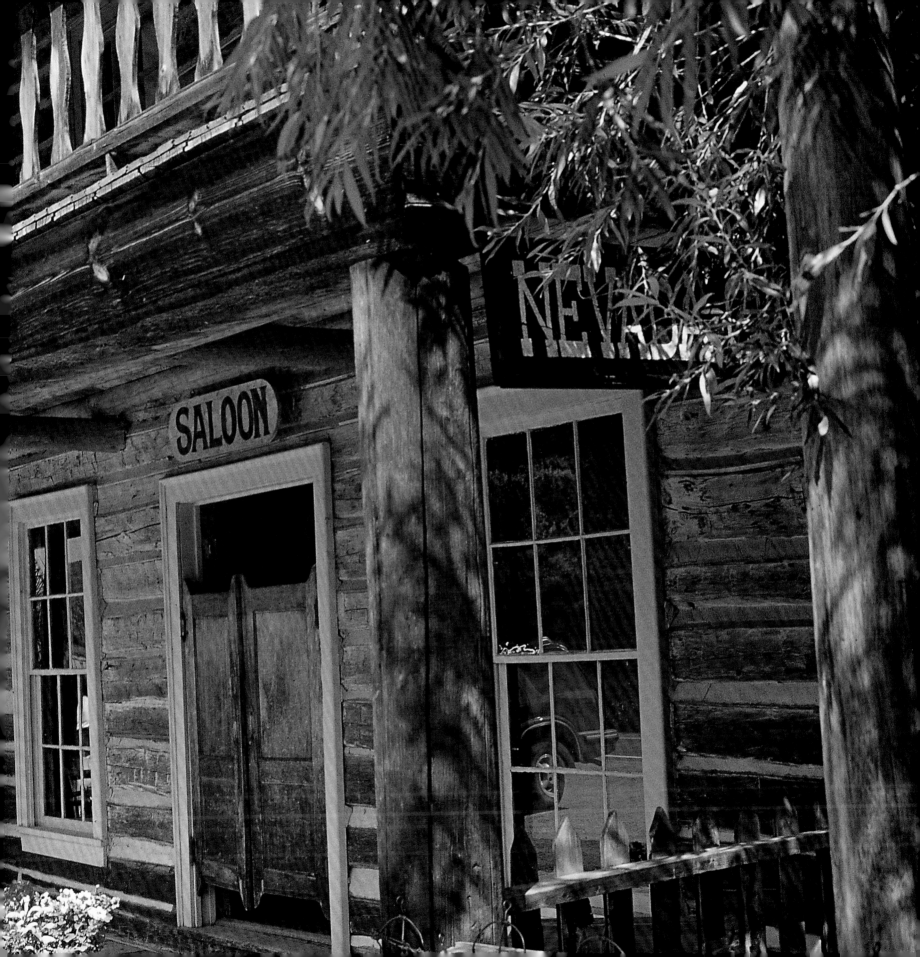

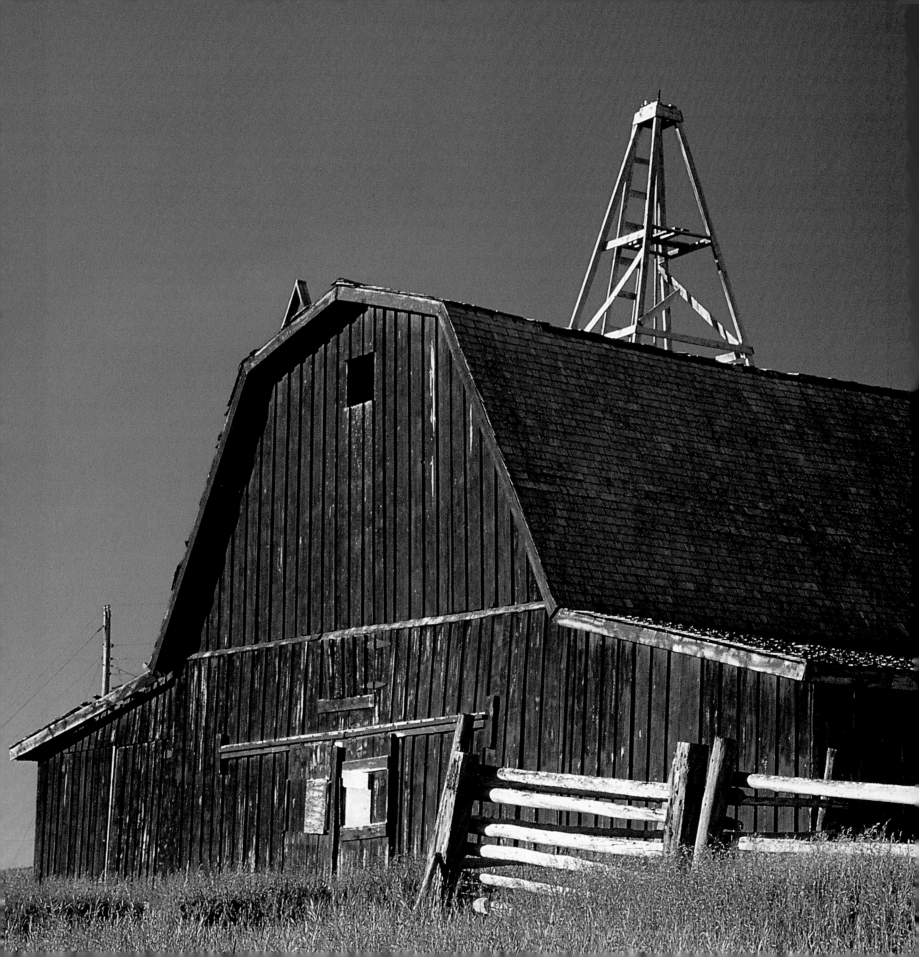

Montana's first home-steaders, many from Eastern Europe, faced difficult challenges — uncleared land, lack of water, scarcity of timber for houses, and the constant threat of prairie fires. Drought and over-grazing eventually forced 60,000 settlers to leave Montana in the 1920s.

47

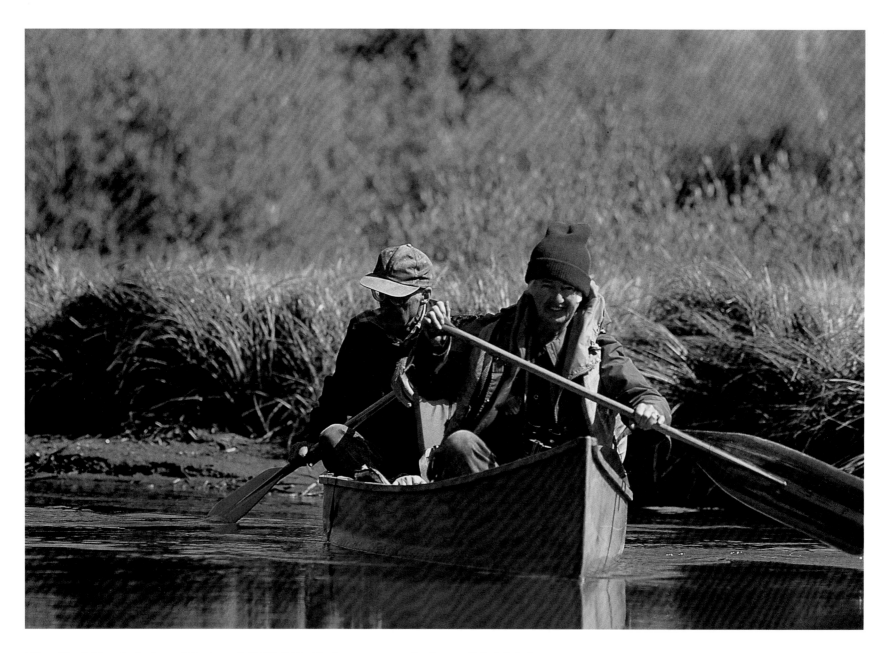

The Red Rock Lakes National Wildlife Refuge extends from 10,000-foot peaks to lush valley wetlands, fed by the runoff from the snows above. For more than half a century, the preserve has protected the breeding grounds of the threatened trumpeter swan.

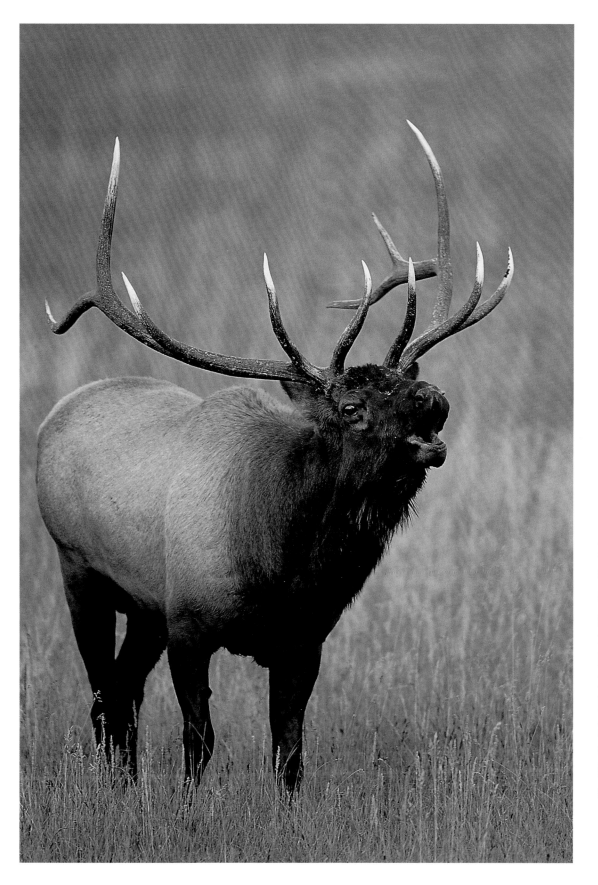

In clearings and along the edges of evergreen and aspen groves, elk herds roam undisturbed by humans in Red Rock Lakes National Wildlife Refuge. Moose, pronghorn antelope, and bighorn sheep inhabit the marshes and mountain slopes.

Before the first European settlers arrived in the 1870s, the wetlands and aspen groves of the Red Rock Lakes area were part of the travel routes of nomadic native peoples, who followed the bison herds to the mountain valleys each summer.

FACING PAGE –
In the early 1900s, thousands of sightseers passed through the Red Rock Lakes region, most by stagecoach, on their way to Yellowstone National Park, 50 miles to the west. Between 1898 and 1902, more than 12,000 passengers traveled the route.

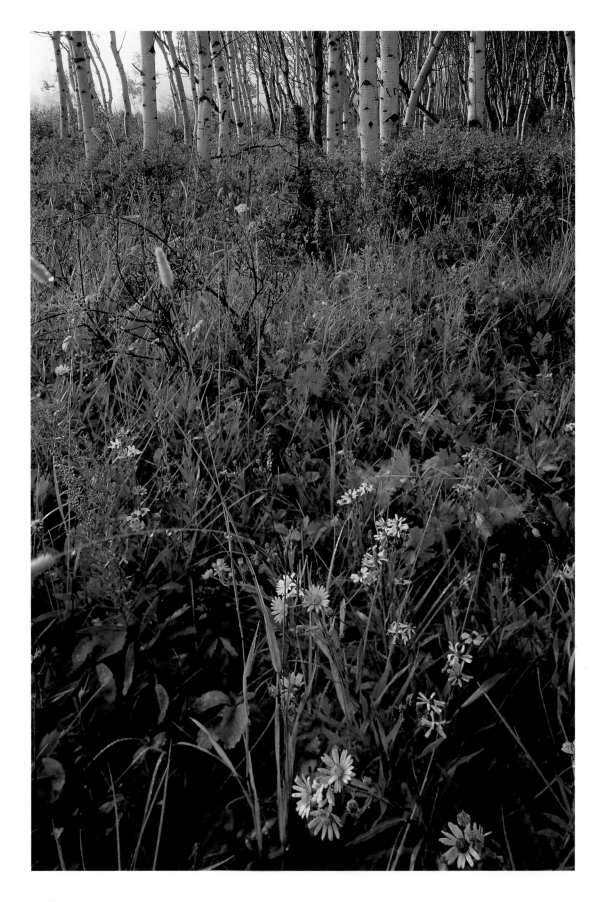

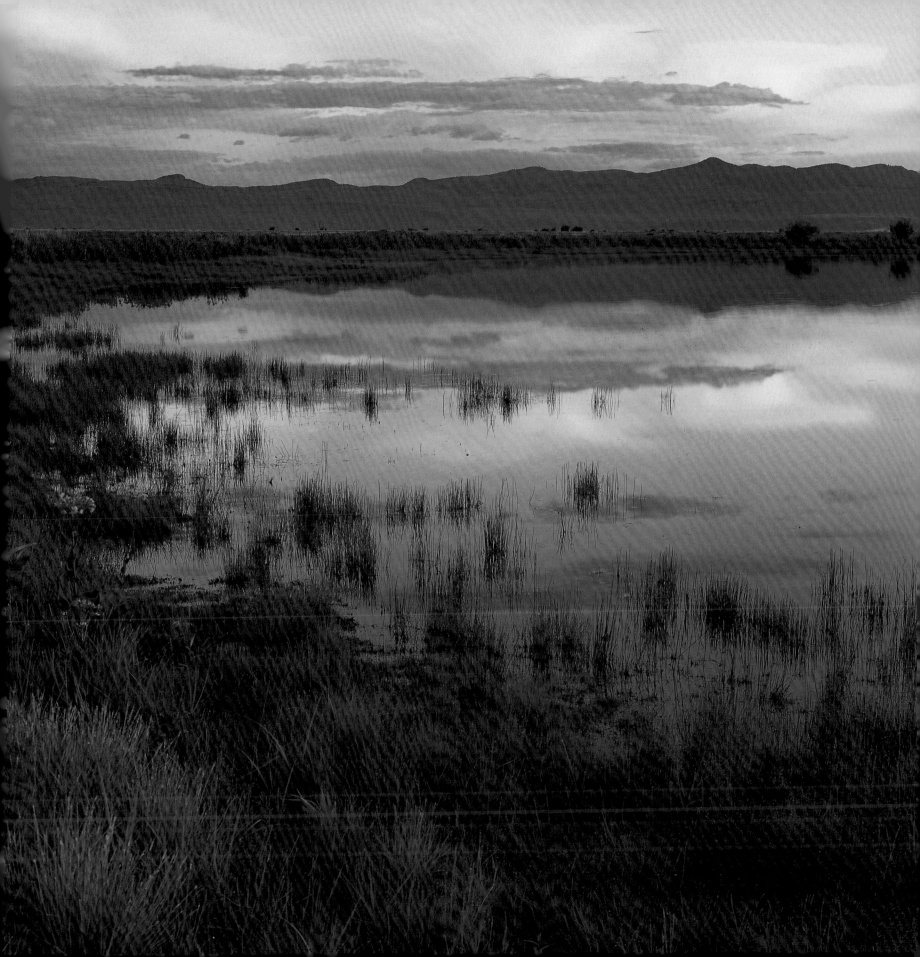

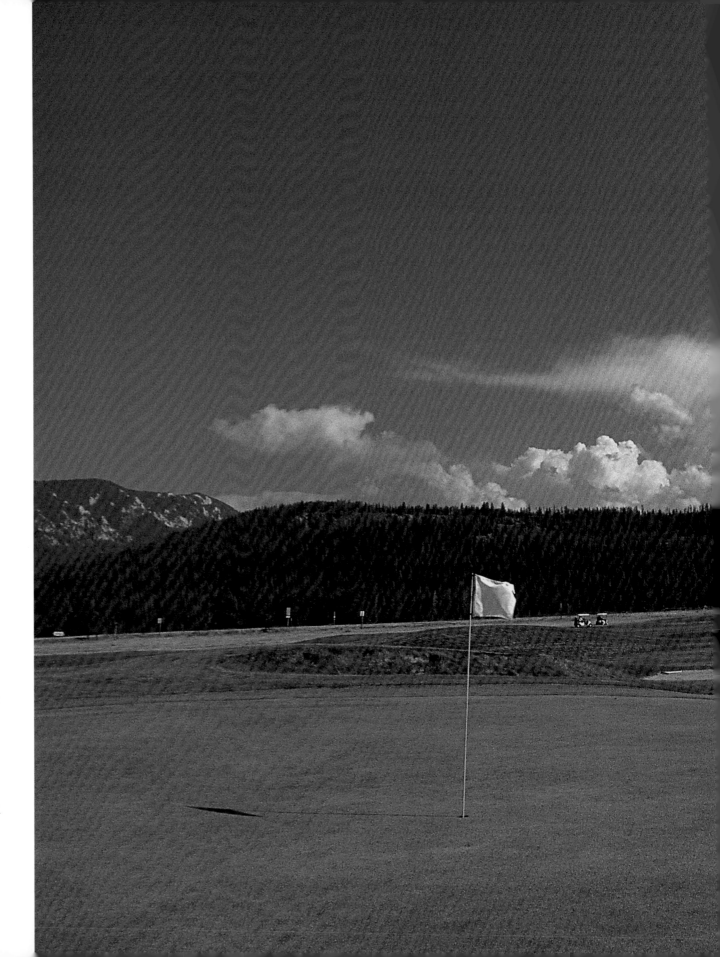

Golfers unhappy
with their scores at
Big Sky Golf Course
can blame the thin
air — the par 72
course, designed
by golf icon Arnold
Palmer, is 6,500 feet
above sea level.

52

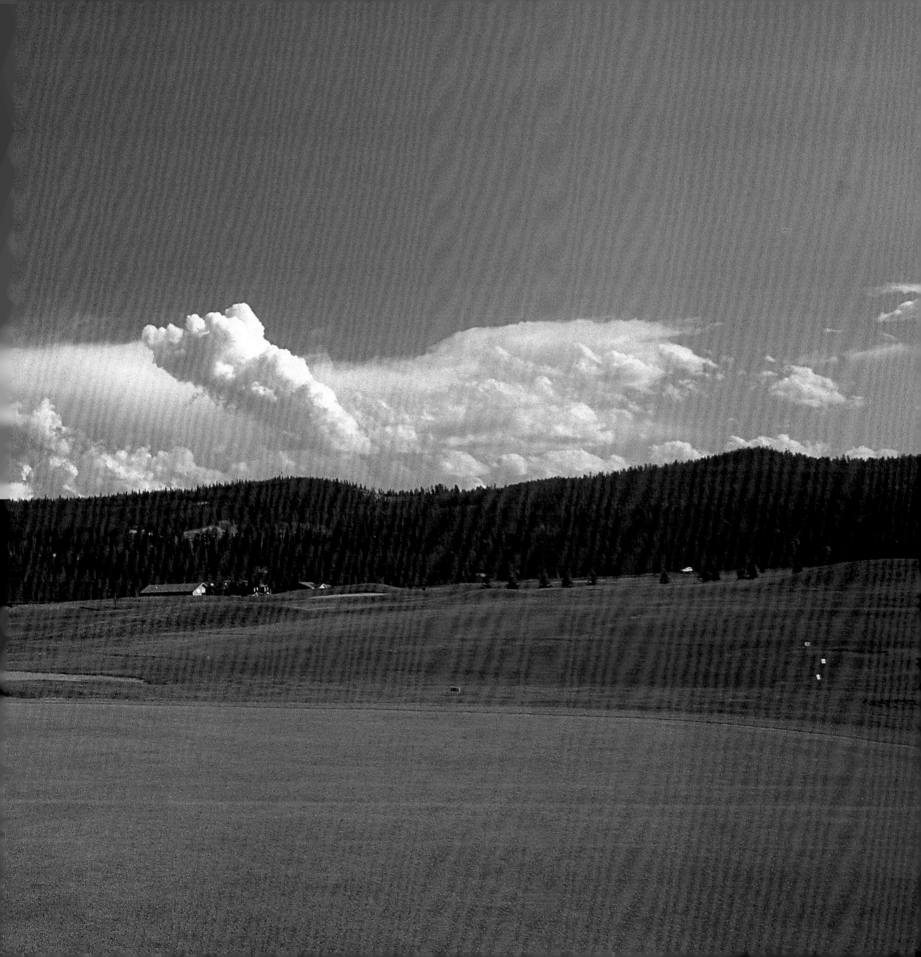

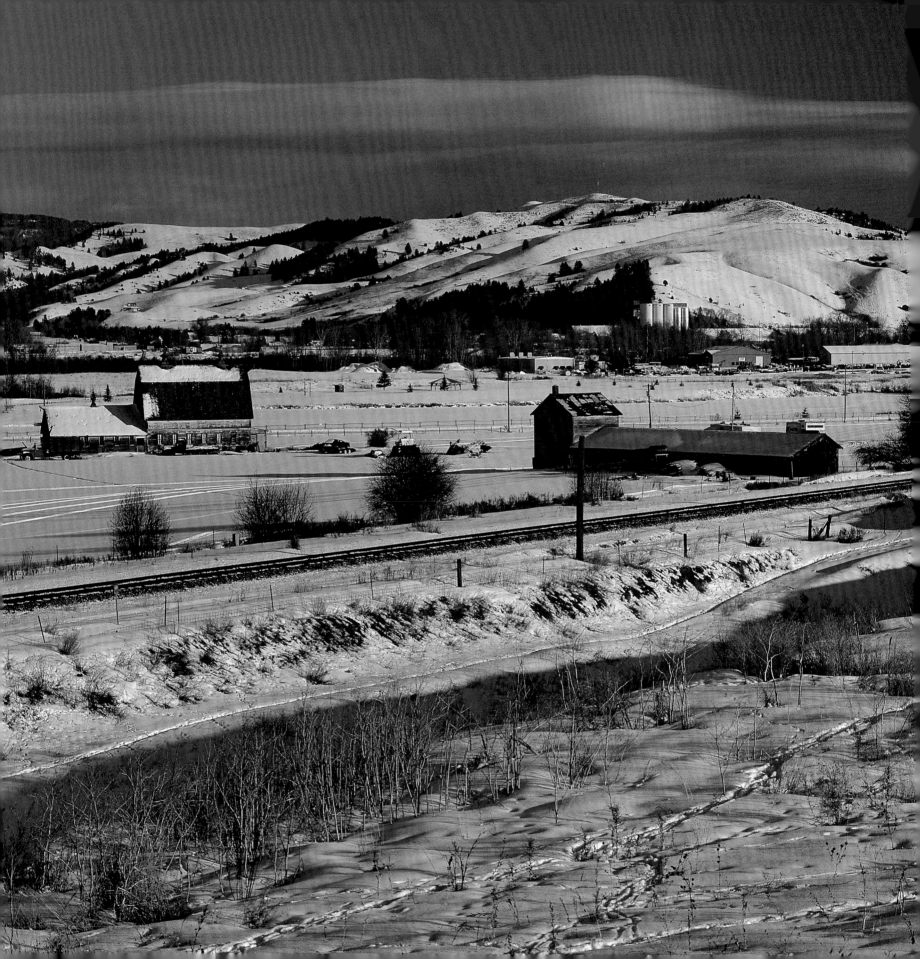

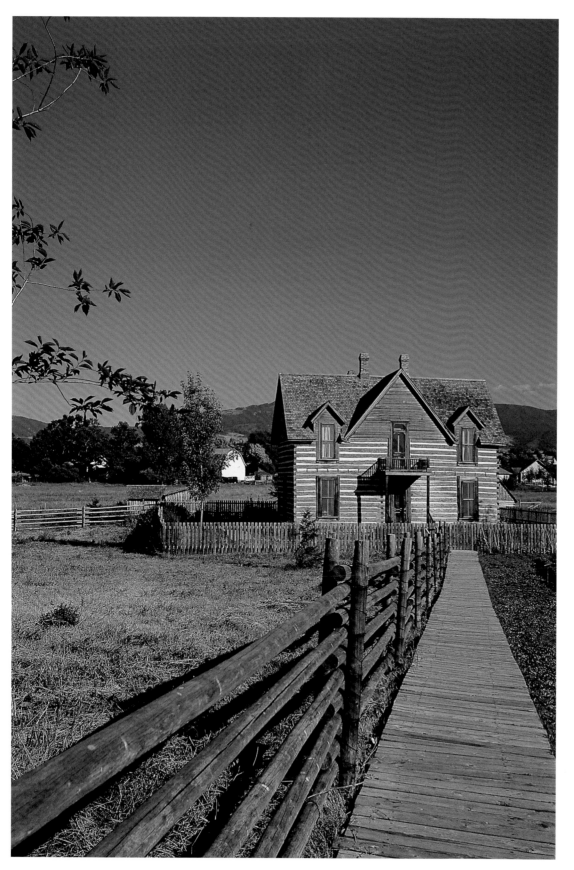

At the Living History Farm, part of Bozeman's Museum of the Rockies, visitors explore an authentic homestead. From cooking to blacksmithing, quilting and gardening, the village brings the daily activities of a century ago back to life.

FACING PAGE –
Arriving even before Lewis and Clark, explorer Pierre la Verendrye may have been the first European to see the peaks of southern Montana. Traveling in the eighteenth century, la Verendrye was seeking a waterway to the Pacific on behalf of the governor of Canada.

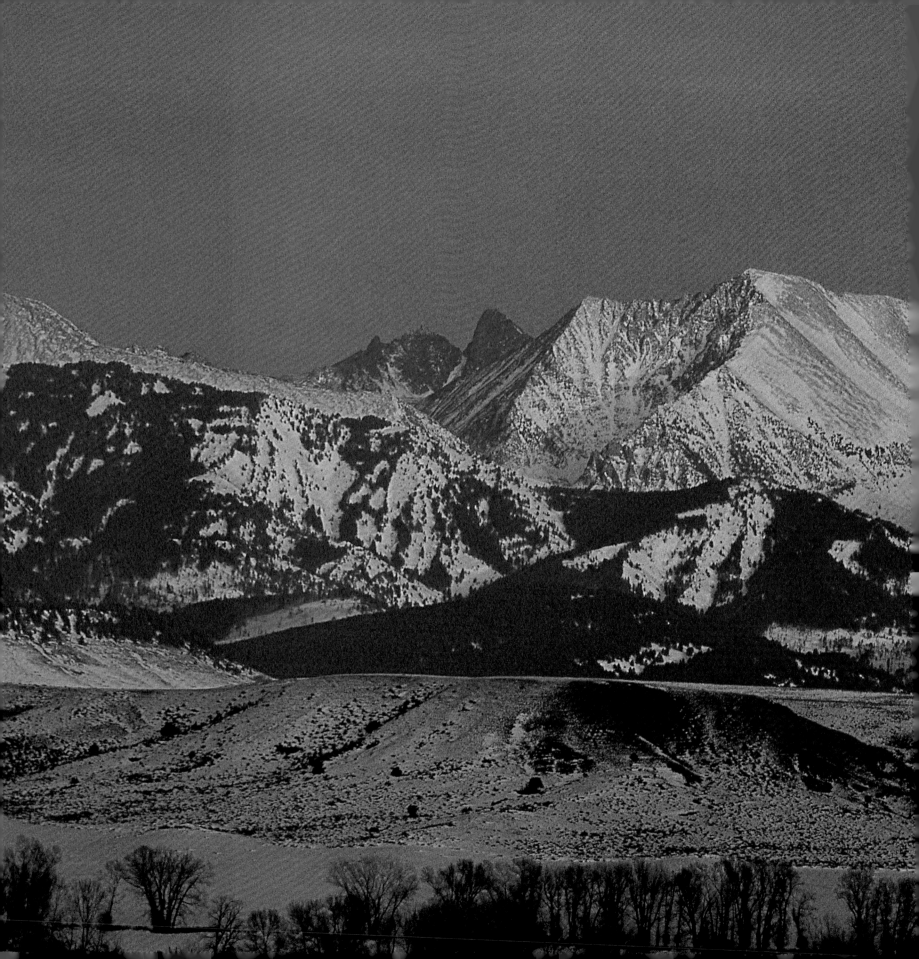

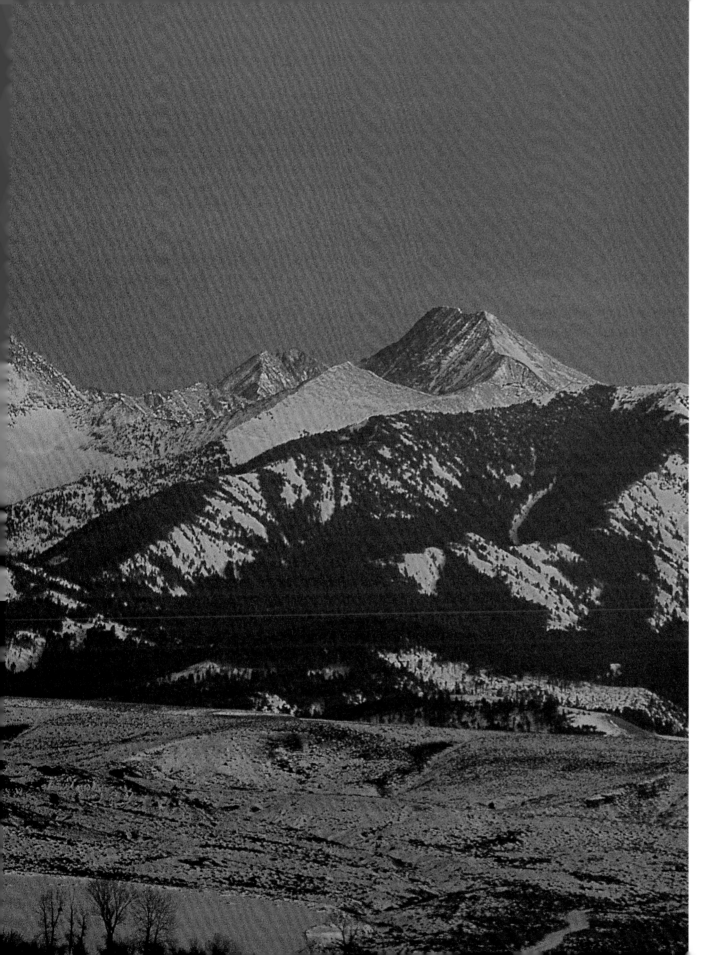

The hills of western Montana hold valuable sapphires — so many that gold miners used to toss them aside, annoyed when the stones caught in their filter screens. Today, of course, the stones are much in demand, and Montana sapphires appear in England's royal crown jewels.

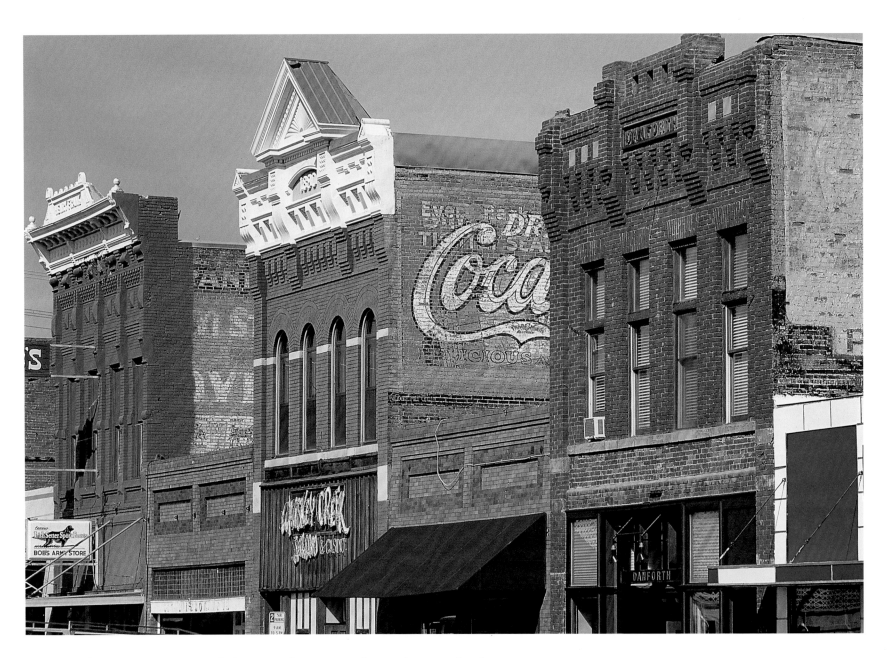

Named for an executive of the Northern Pacific Railway, which sent its first rail line through the area in 1882, the historic town of Livingston is best known as a gateway to Yellowstone National Park.

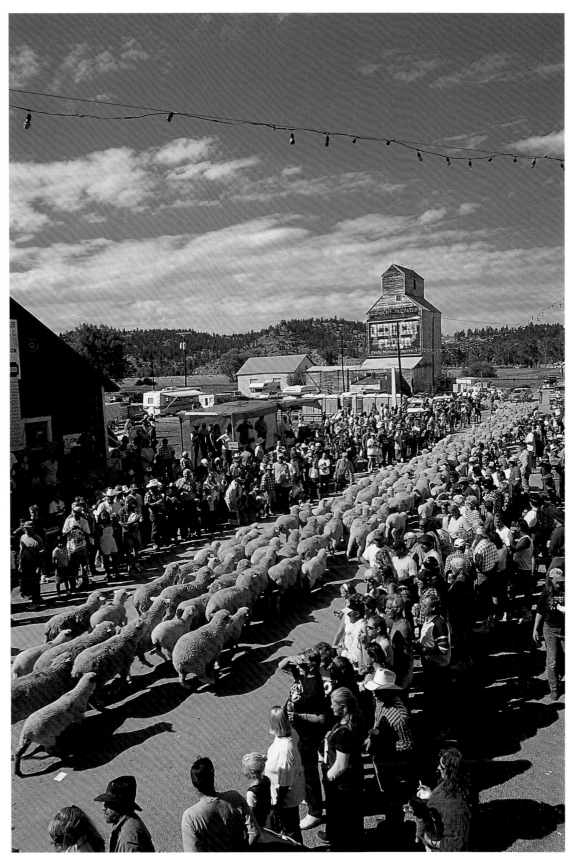

Reedpoint is home to only 100 people, but the annual Running of the Sheep attracts thousands of visitors. First organized in 1989 as a tongue-in-cheek celebration of Montana's centennial, the event proved so popular it's now held each September.

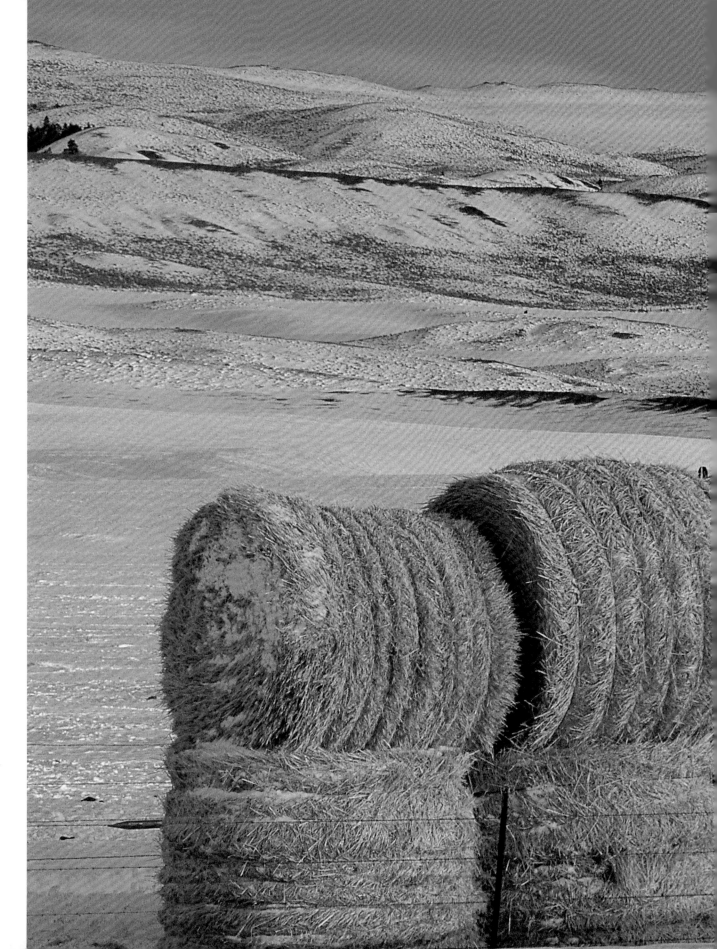

The grasslands that stretch across central Montana offered fodder for bison that roamed the prairie. More than 60 million bison once ranged from Canada to Mexico.

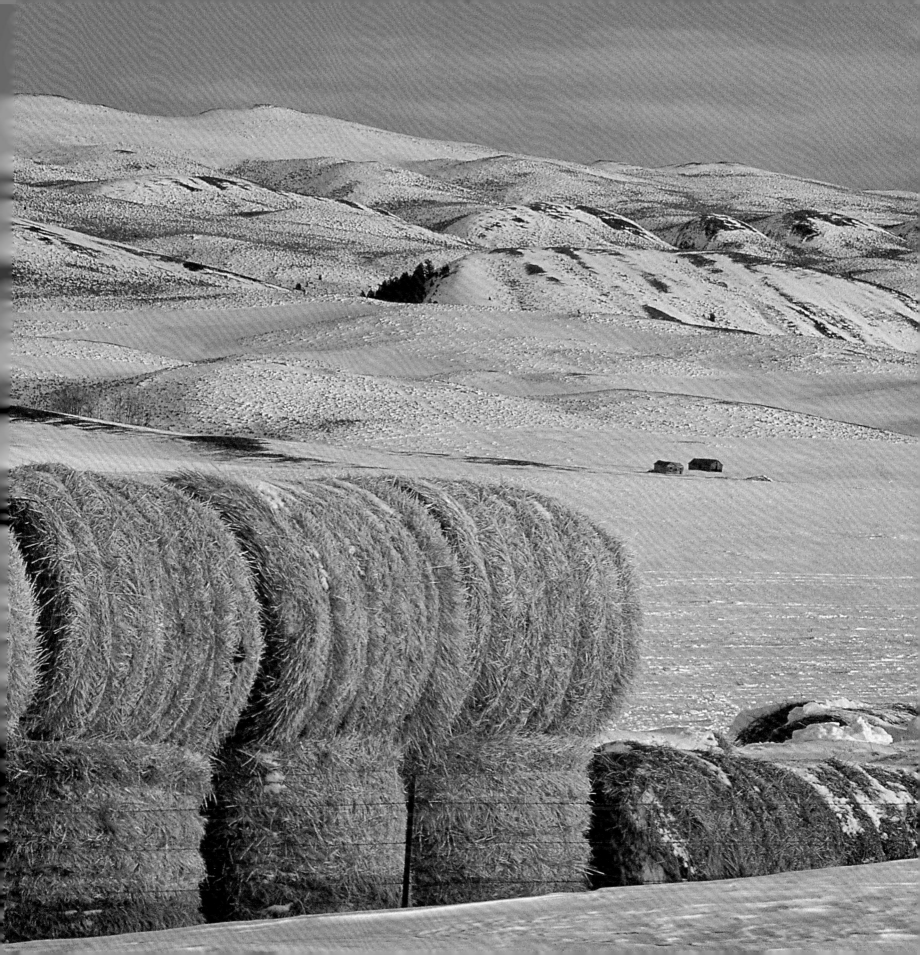

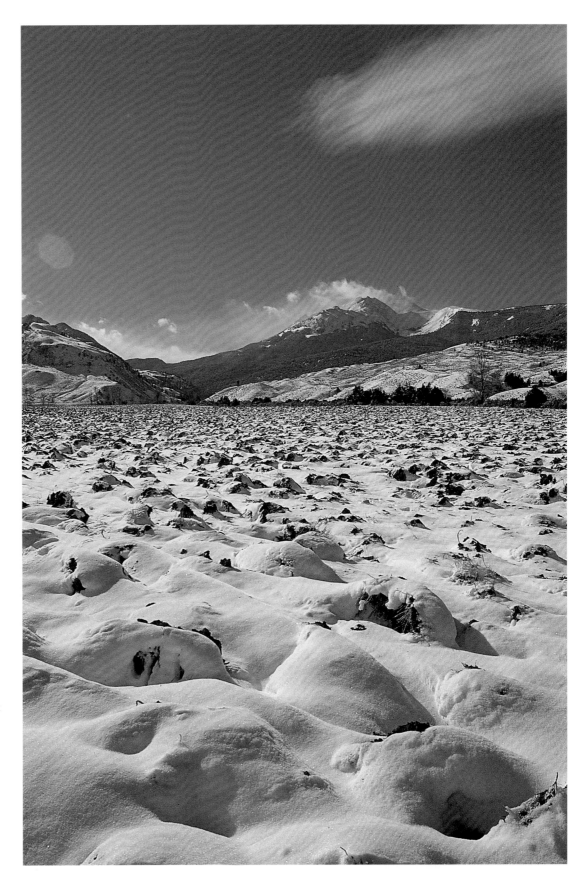

Experienced hikers set out from the community of Corwin Springs to challenge the slopes of Electric Peak, a towering snow-capped mountain just north of Yellowstone National Park.

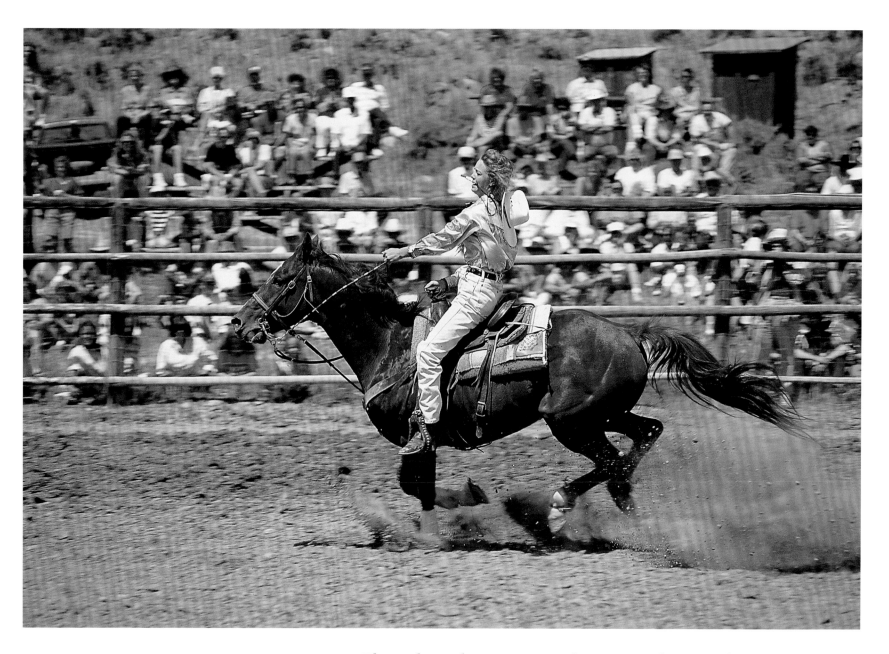

Throughout the summer, rodeos across the state draw crowds with barbecues, parades, dances, and Wild West events from calf roping to bull riding.

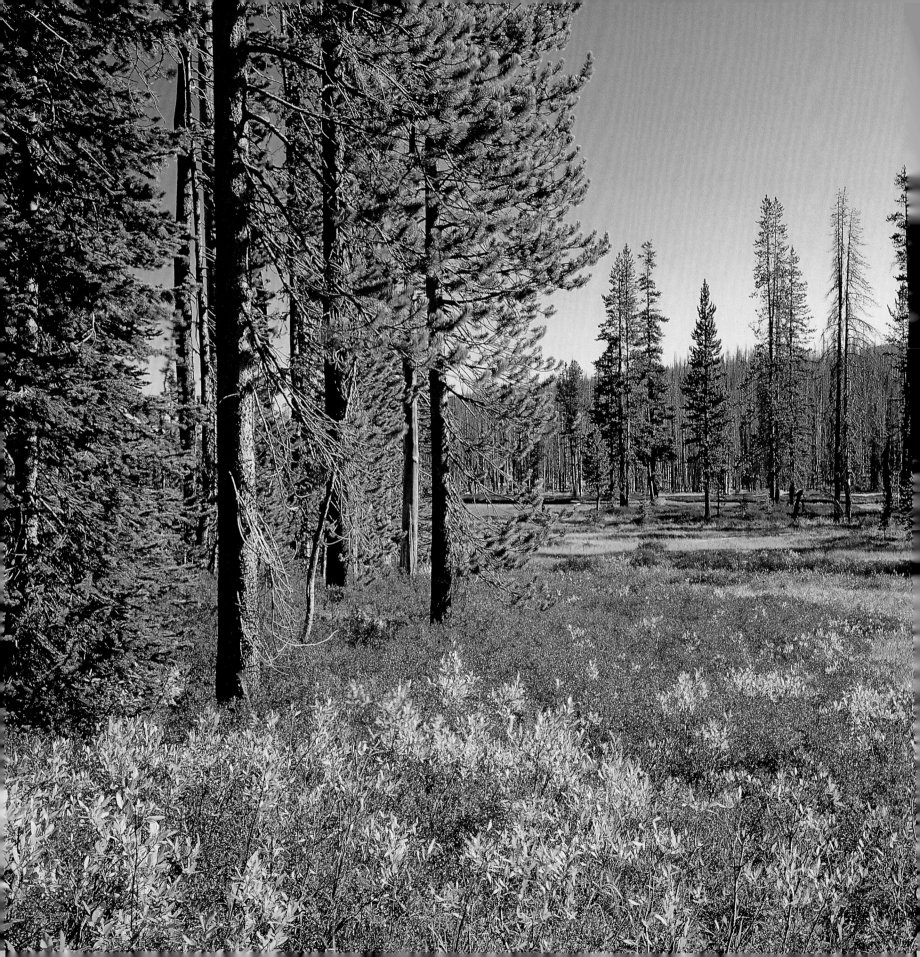

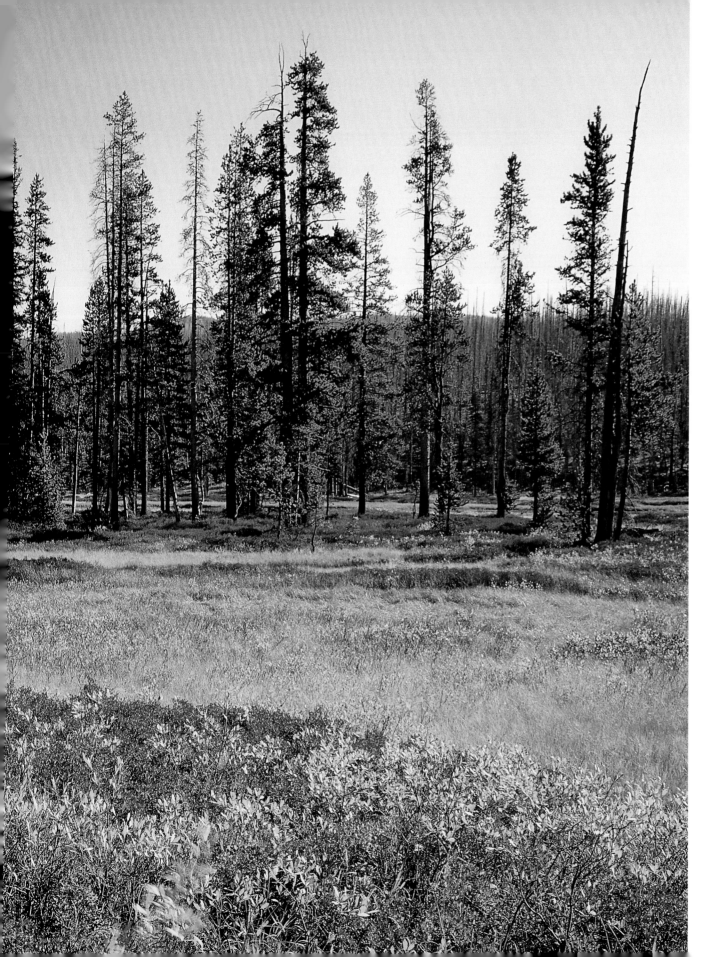

The famed home of Old Faithful Geyser and about 10,000 hot springs, Yellowstone National Park was established in 1872. Only the northern edge of the preserve extends into Montana, but the grizzlies, bison, wolves, and elk that roam the park freely disregard the state line.

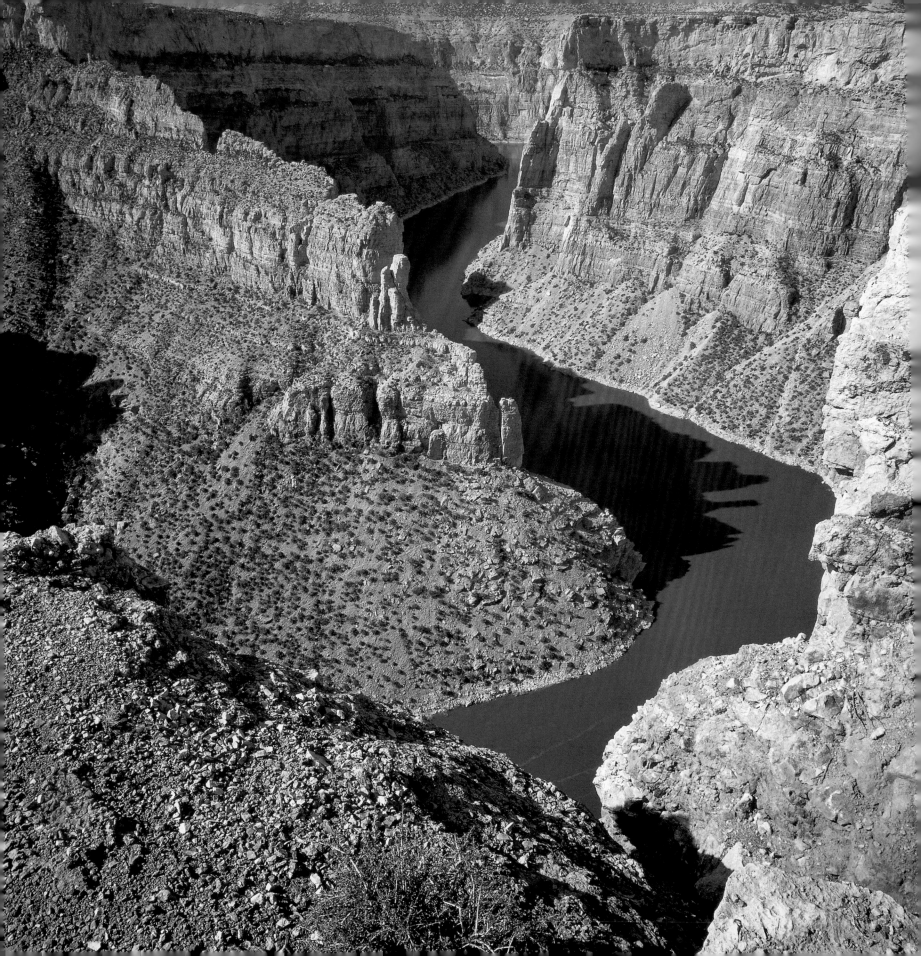

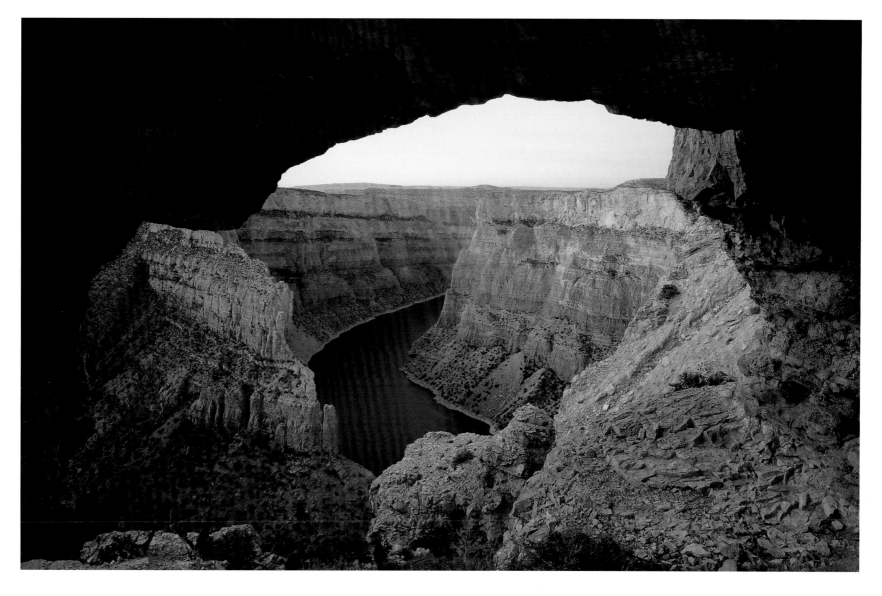

Viewpoints on hiking and biking trails display panoramic Bighorn Canyon from above, while boaters experience the sheer vertical walls from below.

When the Yellowtail Dam was built in the 1960s, waters flooded the 55 miles of Bighorn Canyon and beyond the Montana-Wyoming border. Bighorn Canyon National Recreation Area now protects more than 70,000 acres.

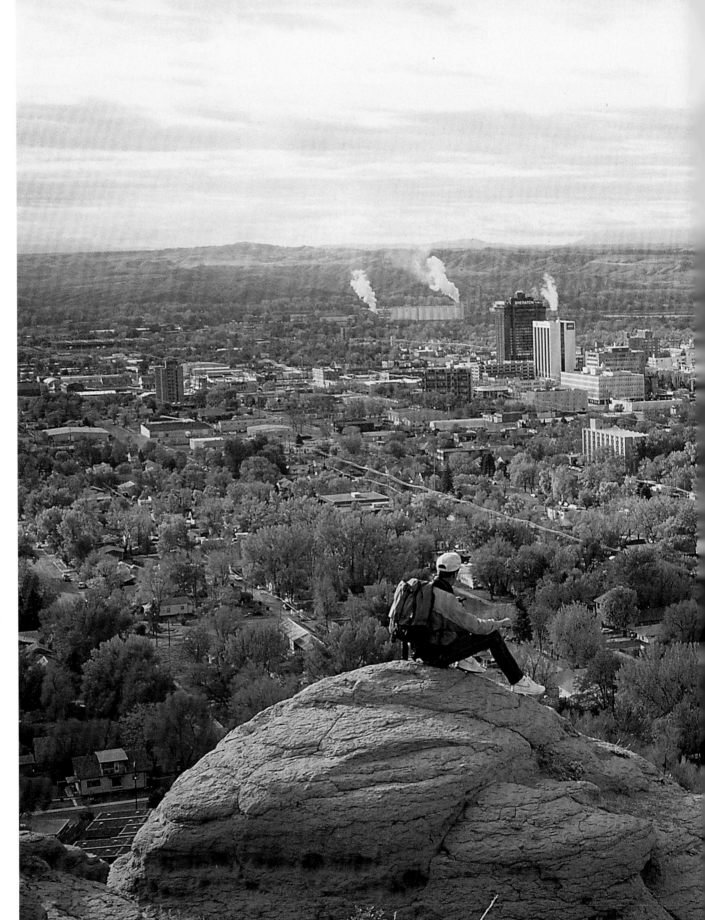

Seen from the Rimrocks at the north side of the city, Billings extends below. First a trading post and stagecoach stop named Coulson, the city was renamed for Northern Pacific president Frederick Billings when the railway reached this part of the state.

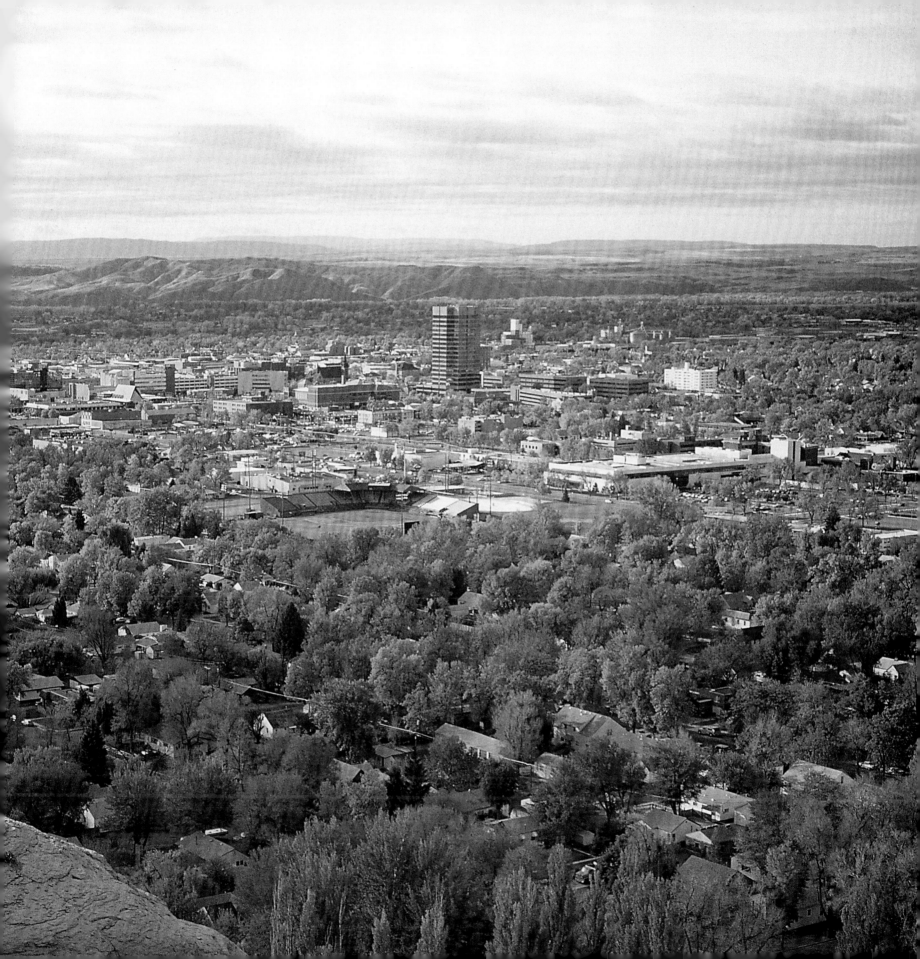

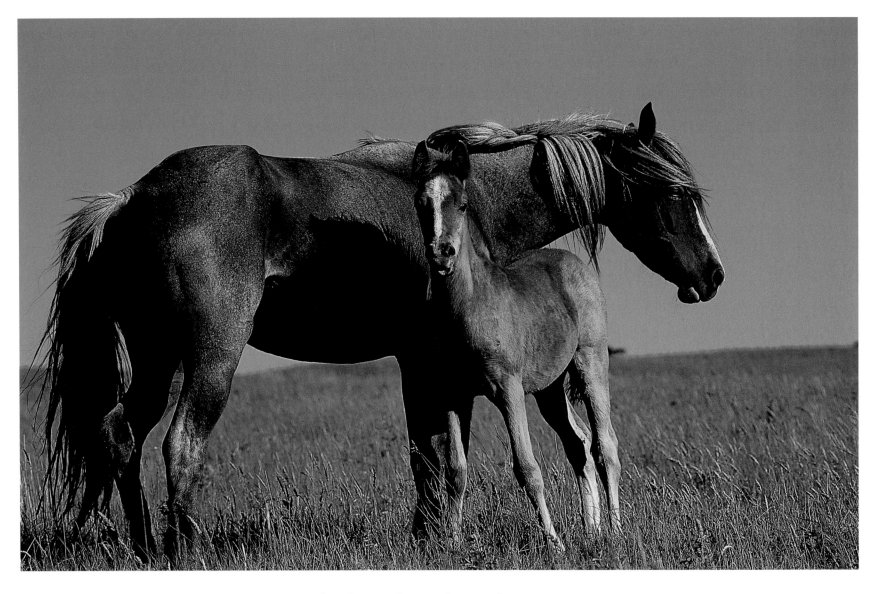

The mustangs that roam Montana's grasslands are descendants of the horses brought to North America by the Spanish explorers of the 1500s. The horses are protected by the federal government.

Commissioned by Preston B. Moss, one of the richest men in early Montana, the Moss Mansion today preserves a taste of high society in turn-of-the-century Billings.

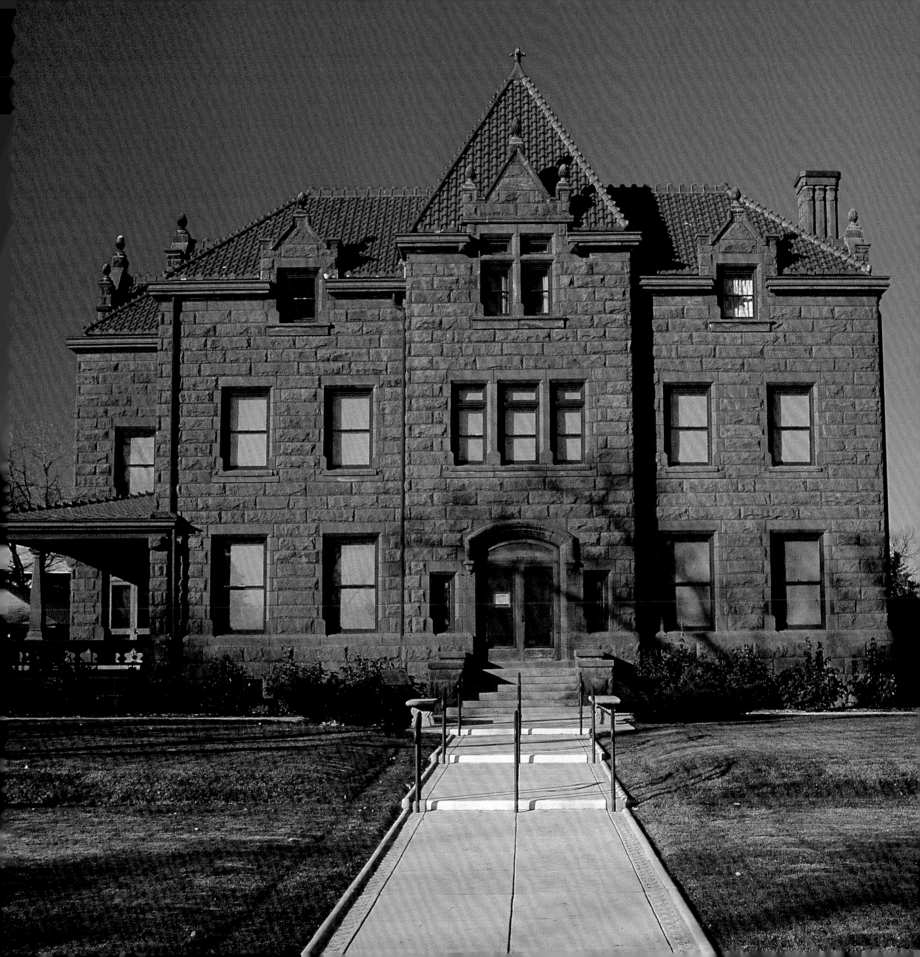

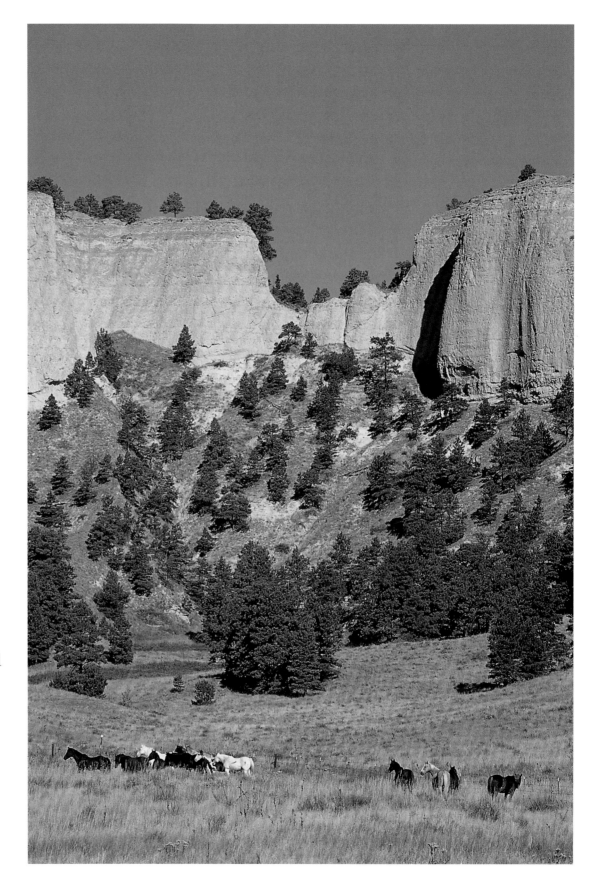

The fourth-largest state in the nation, Montana is home to only 900,000 people. Much of the rugged land (Montana's name comes from a Latin word meaning "mountainous") remains as it was when Lewis and Clark traversed the territory.

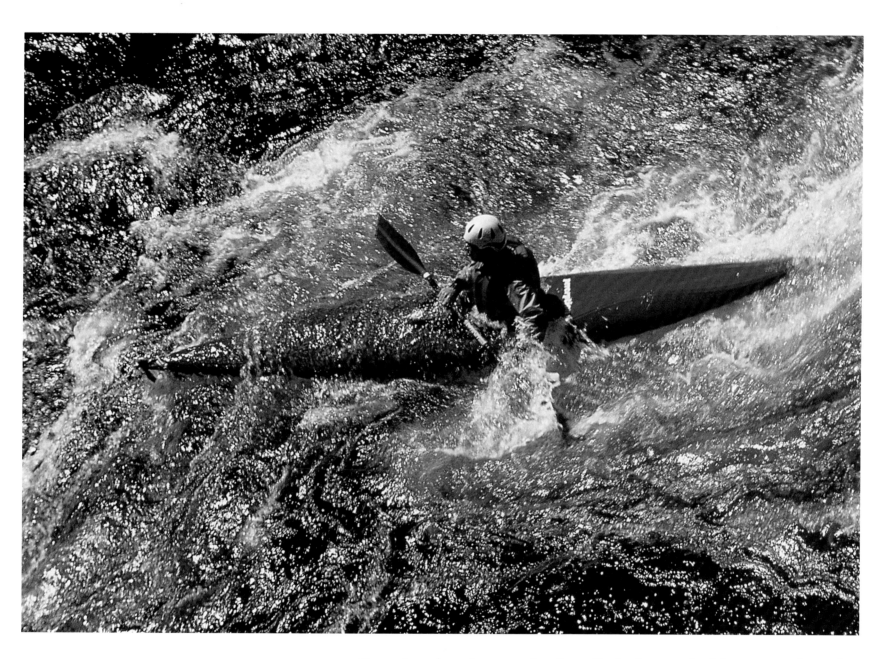

Canoeists, kayakers, and rafters find plenty of white water along the swift-flowing Yellowstone River or the challenging Gallatin. Guided trips allow even novice paddlers to discover the thrill of the rapids.

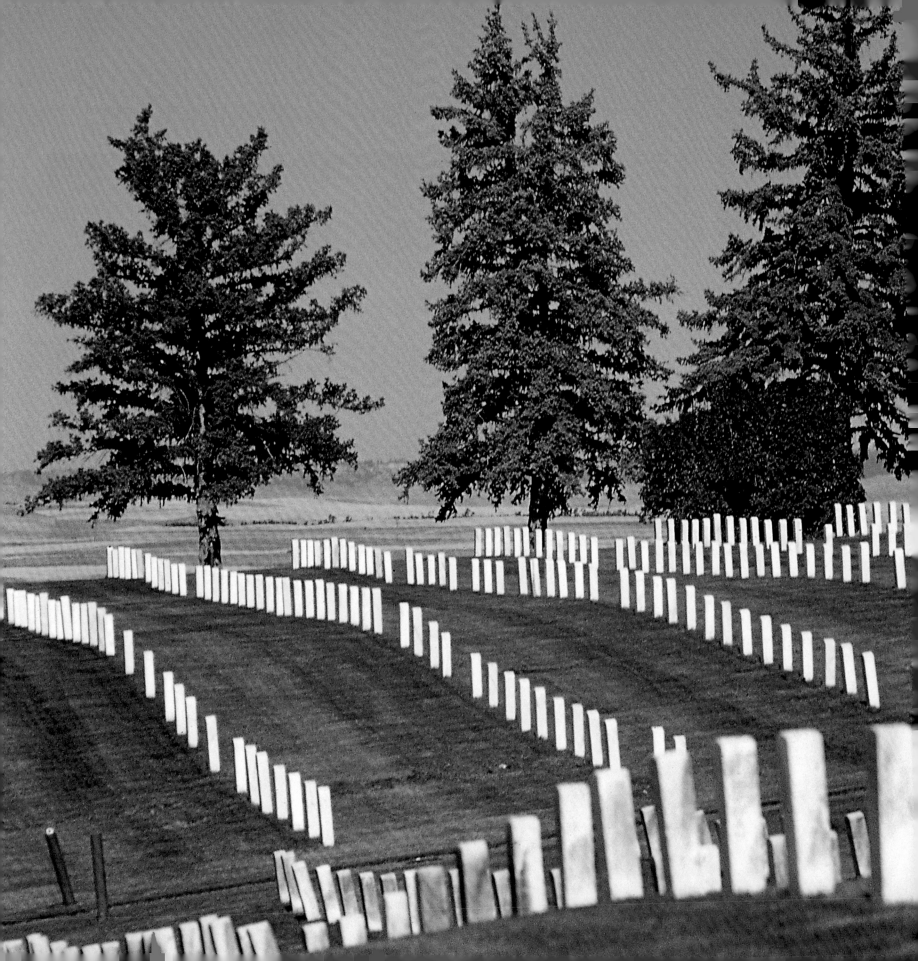

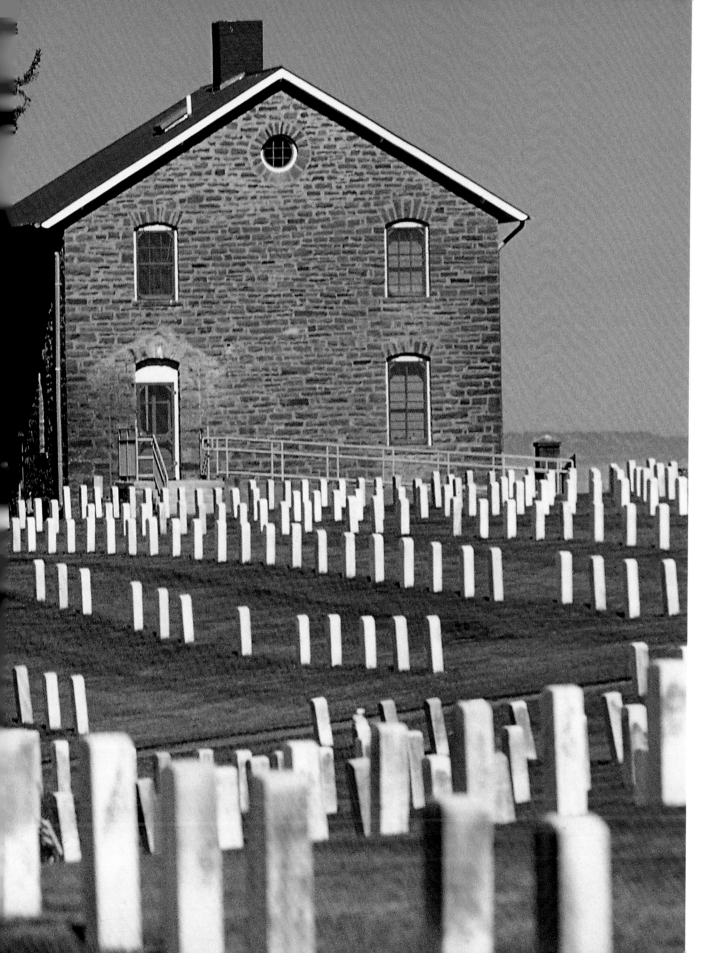

In June 1876, General Custer made his legendary "Last Stand" against Lakota, Cheyenne, and Arapaho warriors at Little Bighorn Battlefield, now a national monument. The graves here commemorate the fallen from the Army's 7th Calvary. The native people who died were laid to rest by their families at traditional sites.

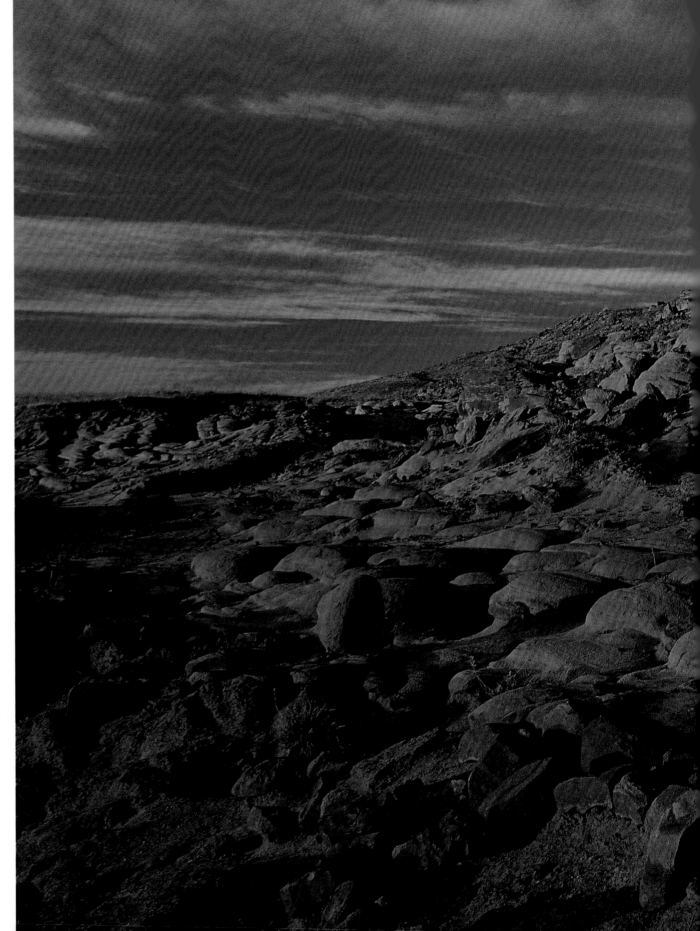

The badlands near Choteau hide some of the most fascinating fossils ever discovered. Preserved dinosaur nests, complete with eggs, young, and adults, were discovered here, offering paleontologists a look at the maiasaur's family life 80 million years ago.

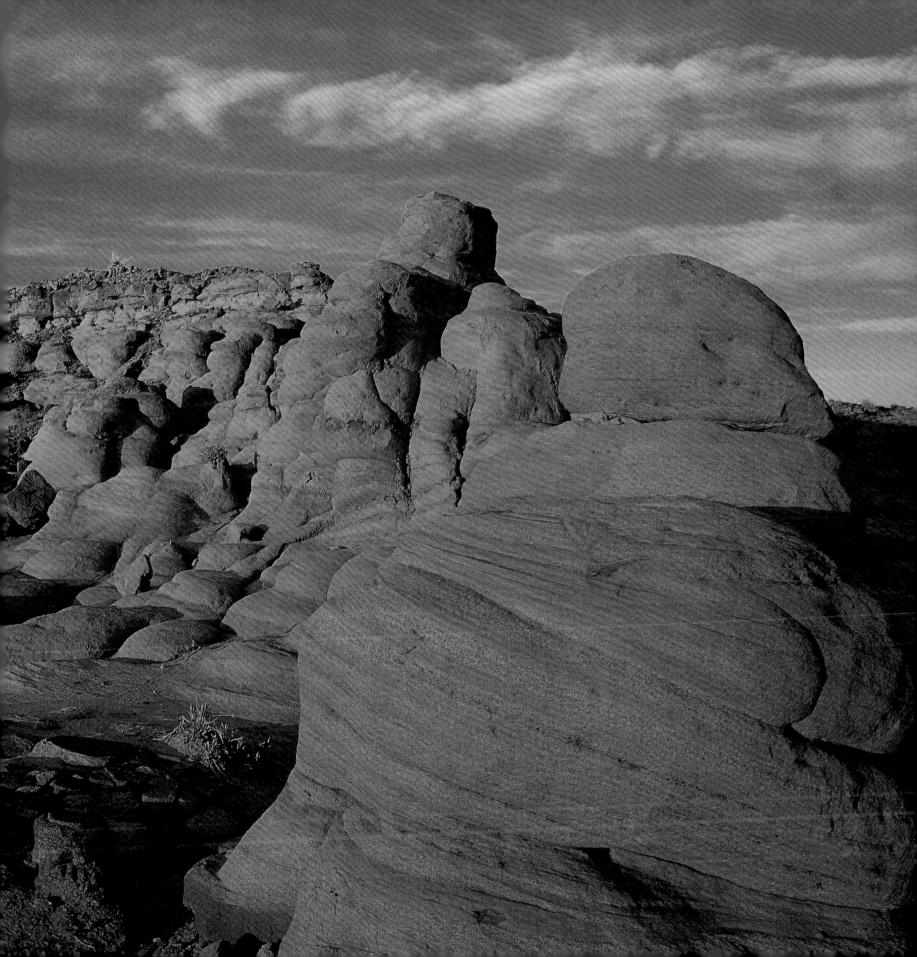

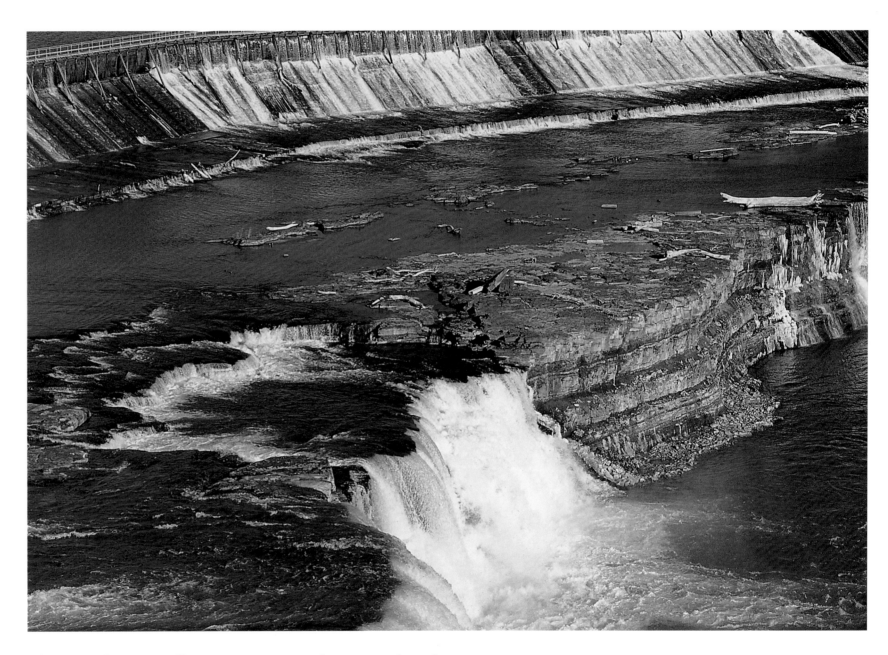

The city of Great Falls was incorporated in 1888, less than a century after Lewis and Clark portaged around the roaring Missouri River waterfall. The falls now power a hydroelectric dam.

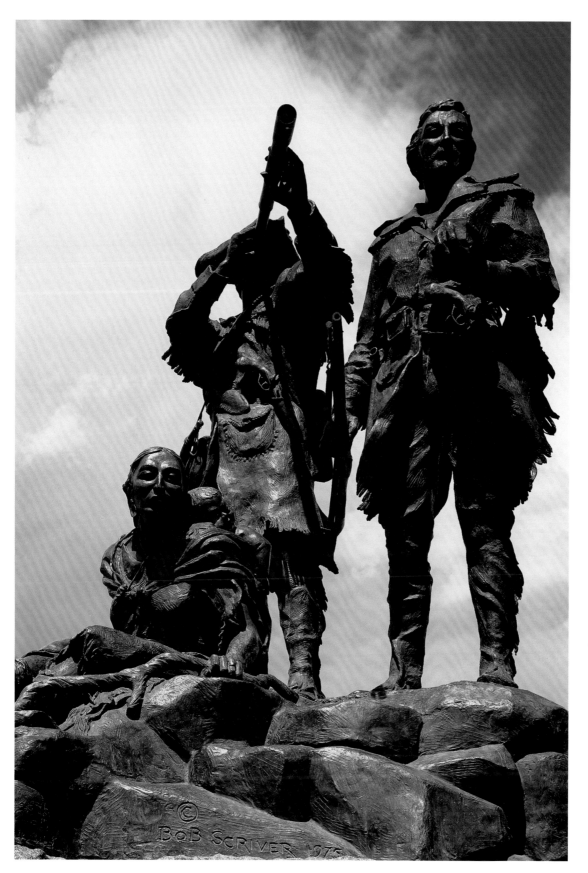

This statue in Fort Benton commemorates the transcontinental journey of explorers Meriwether Lewis and William Clark, along with their guide Sacajawea. The group was searching for an all-water route across the New World.

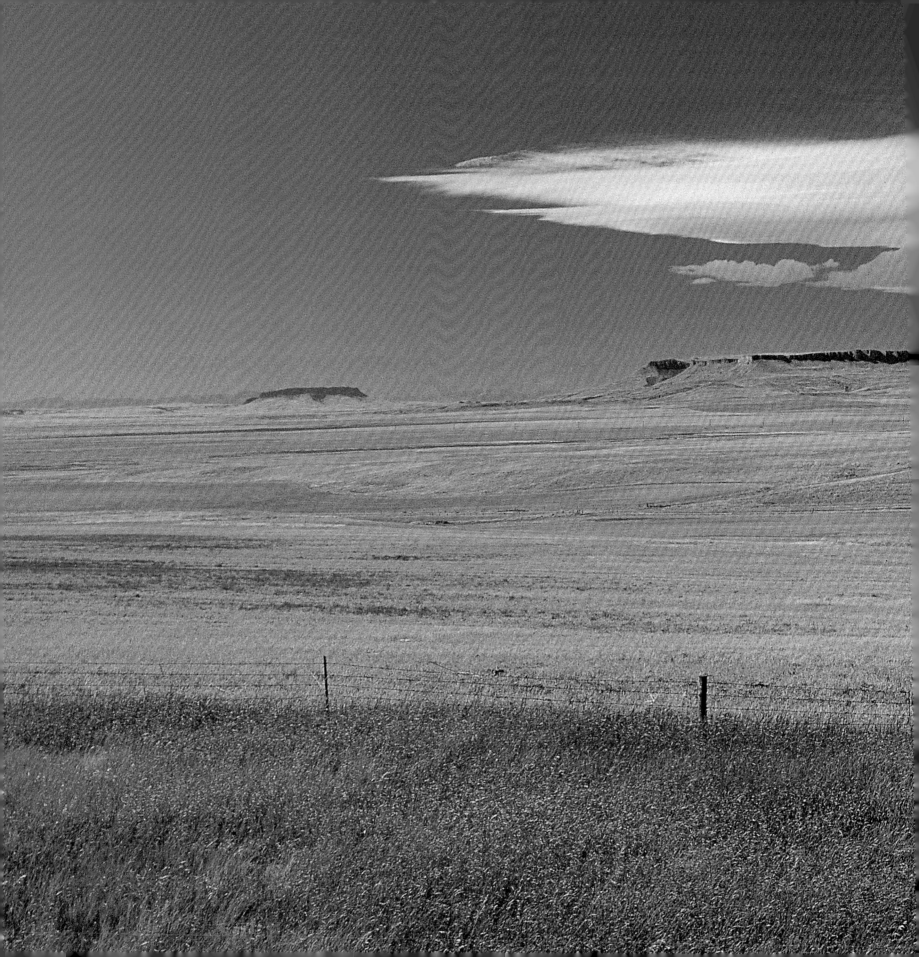

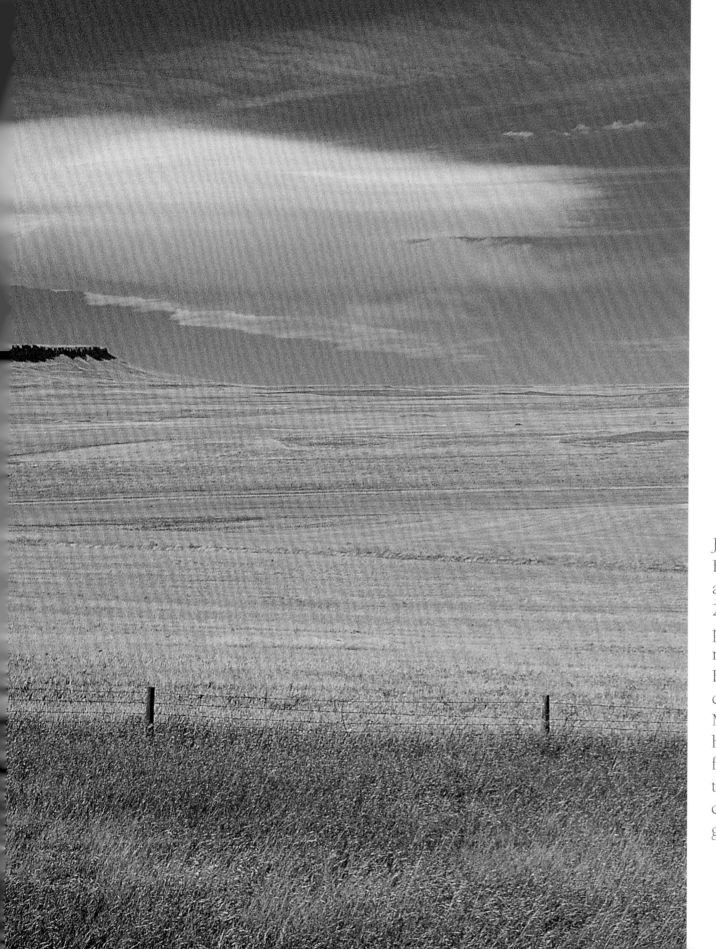

Just south of Fort Benton, Square Butte's arresting profile rises 2,400 feet from the plains. Formed by movements of the Earth's crust, then carved by glaciers, Montana's landscape holds many forms, from eerie pinnacles to sheer canyons, that continue to intrigue geologists.

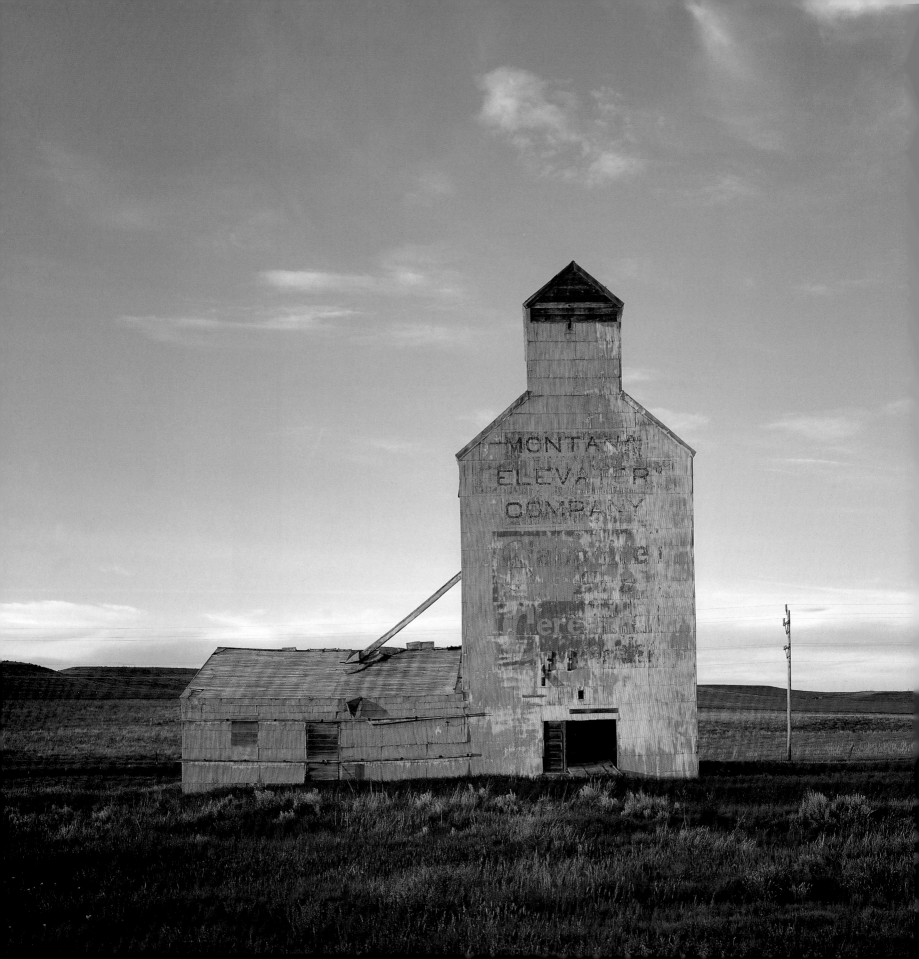

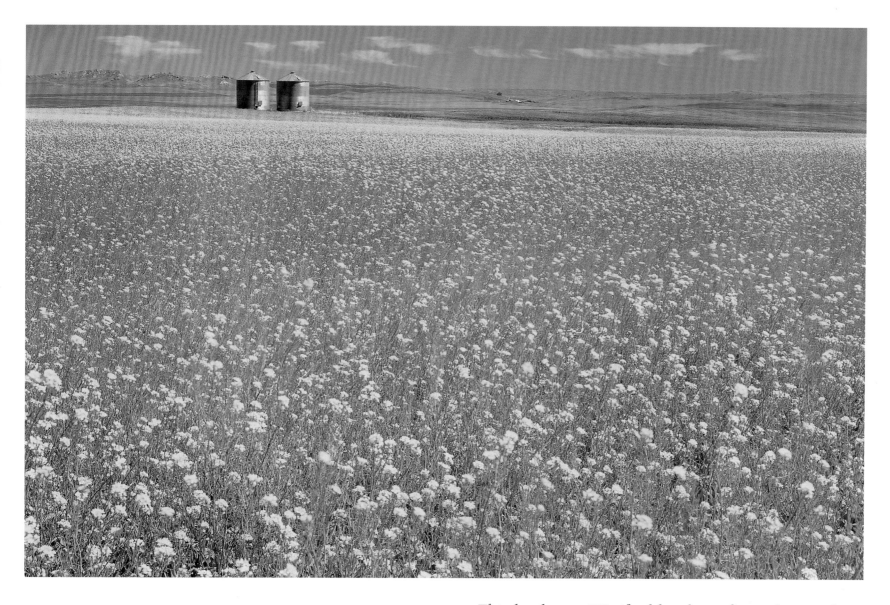

This land near Winifred has been farmed since the first settlers arrived in the area in 1884.

An abandoned grain elevator stands amid the fields of Fergus County. This landscape inspired artist Charles Russell, who arrived in 1880 and began painting cowboys, cattle ranges and the Wild West.

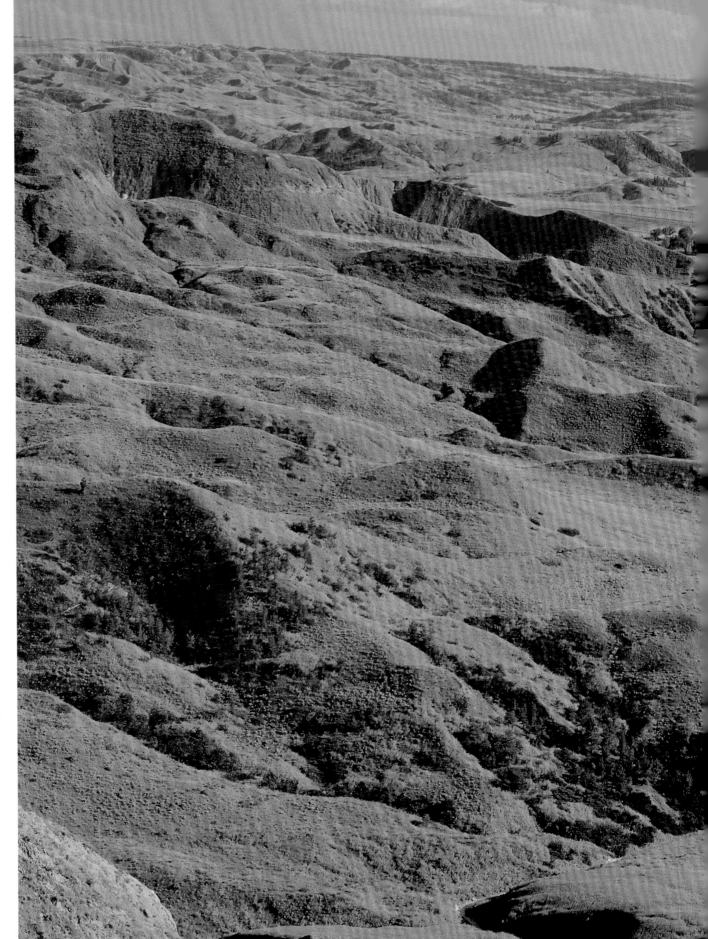

Judith River, a tributary of the Missouri, flows through lush valleys. Secluded forest groves shelter elk, whitetail deer, and moose, along with small mammals and countless bird species.

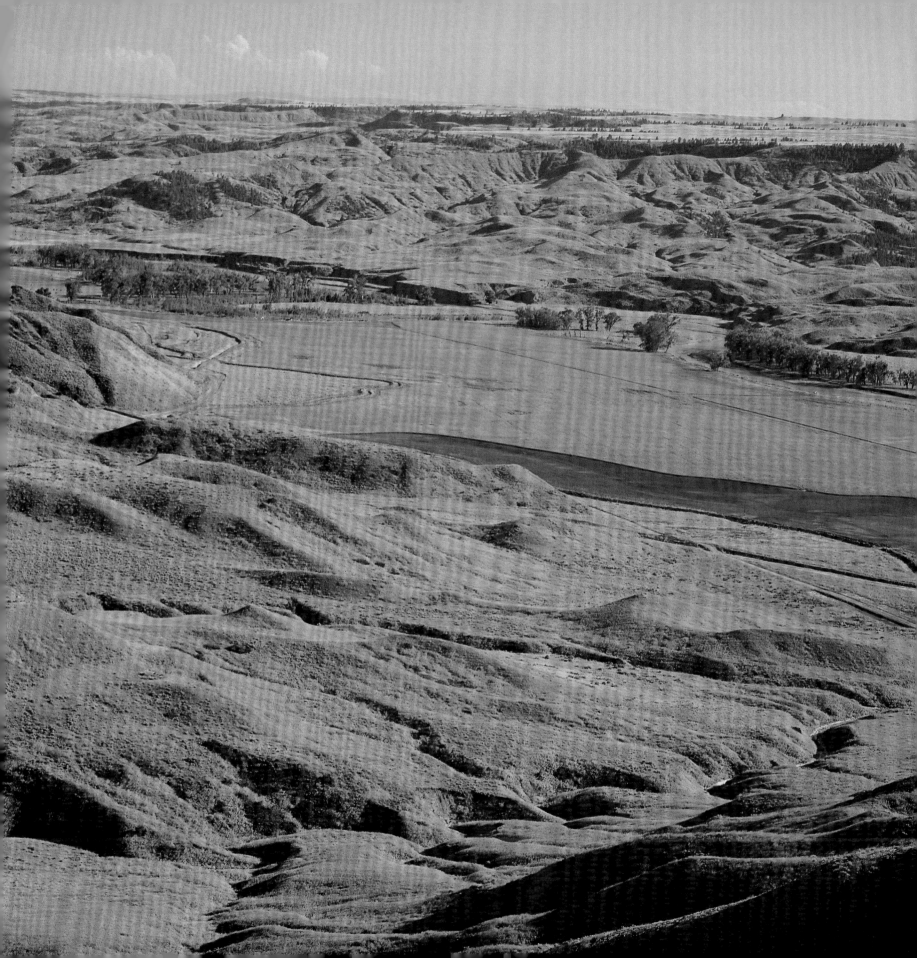

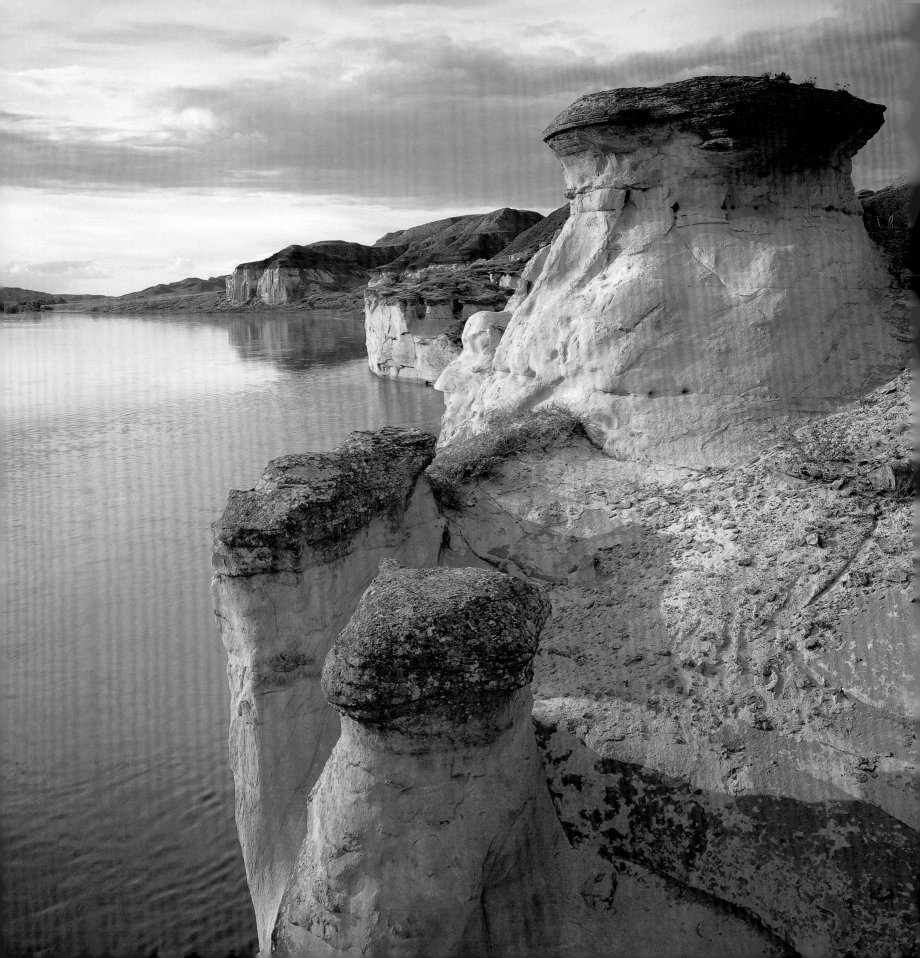

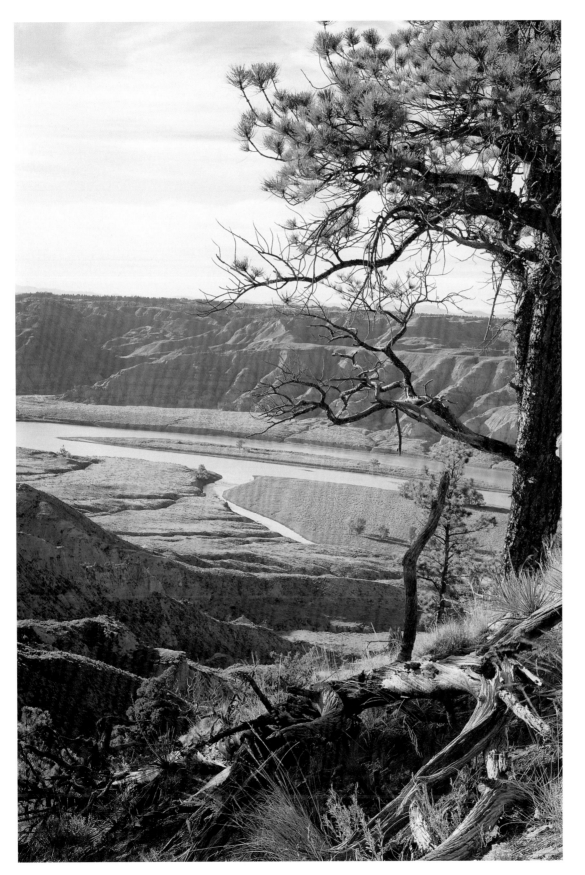

In northern Montana, 149 miles of the Missouri River known as the Upper Missouri Breaks appear much as they did when explorers arrived centuries ago. Residents and environmentalists have fought to ensure that the region remains untouched.

FACING PAGE –
Long before the arrival of Europeans, native groups along the Missouri River used the waterway for trade and travel. French Canadian explorers first encountered the river in 1673, and Lewis and Clark became the first Europeans to trace it to its source in the early 1800s.

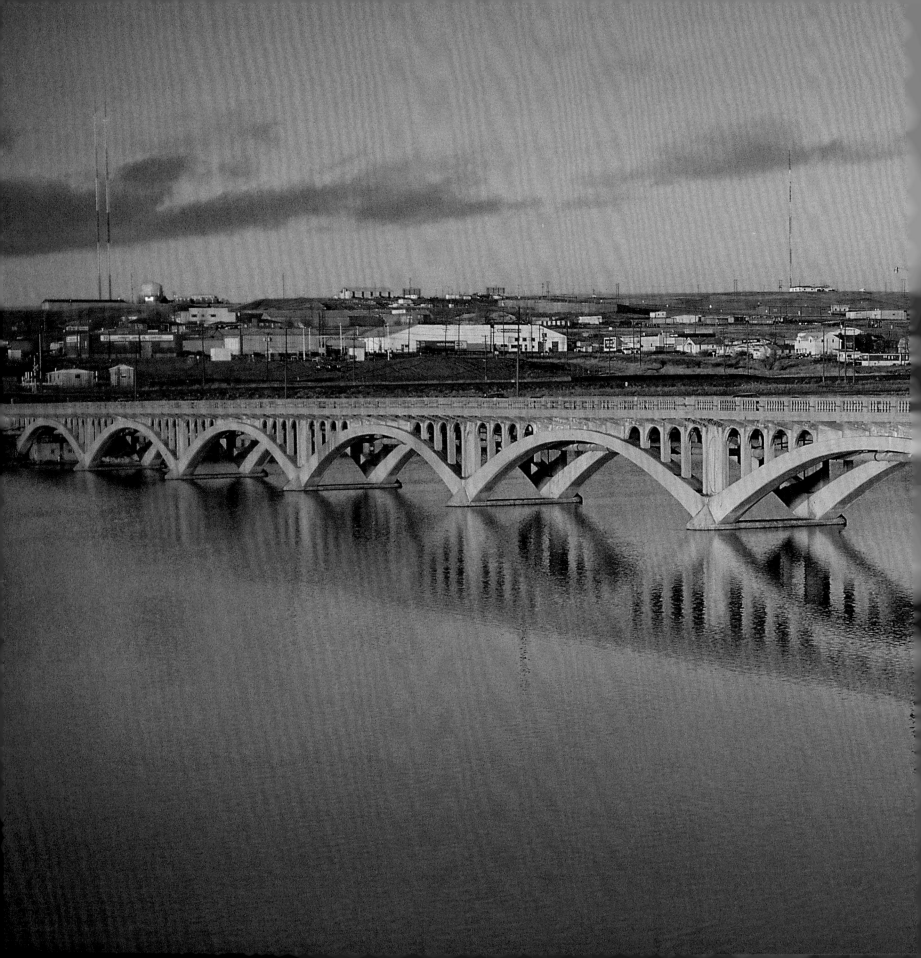

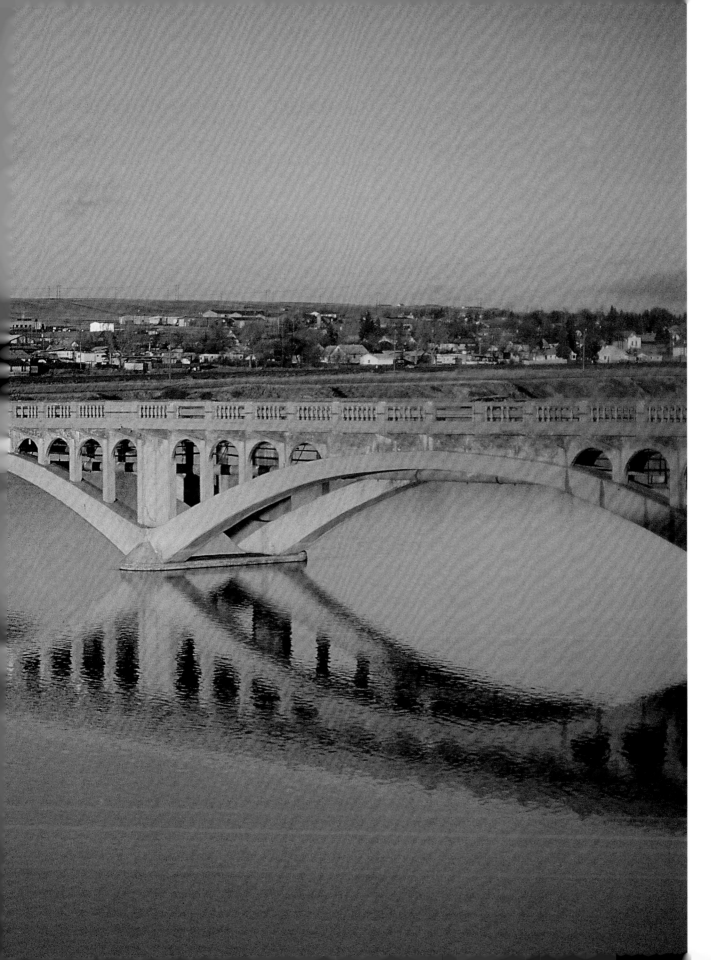

America's longest river, the Missouri drains more than 500,000 square miles, including parts of Montana, Nebraska, South Dakota, North Dakota, Wyoming, Kansas, Missouri, Colorado, Iowa, and Minnesota.

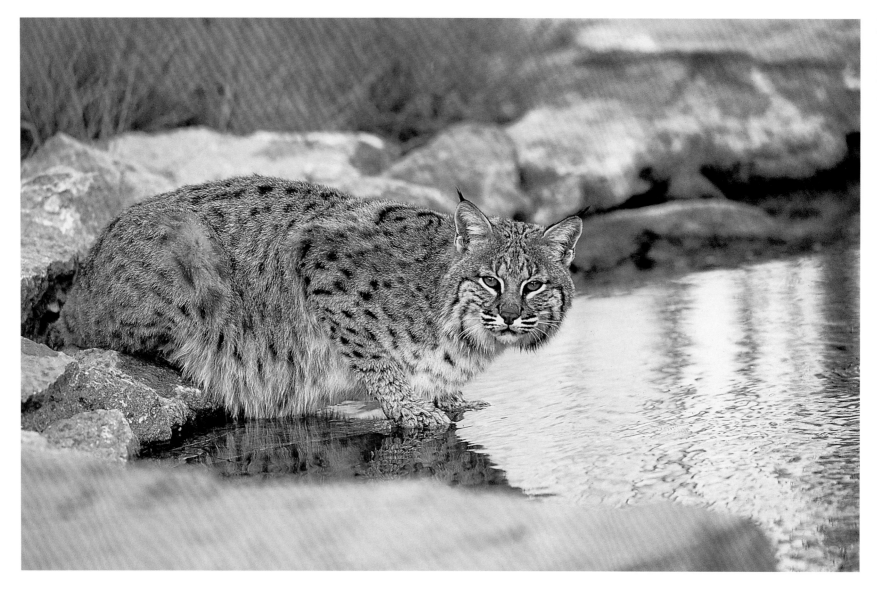

This bobcat may hunt during the day or at night, roaming 4 to 15 square miles in search of rats, mice, rabbits, squirrels, and insects. Because of its varied diet, it can adapt to forest or wetlands.

Named for painter Charles Russell, the C. M. Russell National Wildlife Refuge encompasses more than a million acres along the Missouri River. The refuge protects a diversity of habitat.

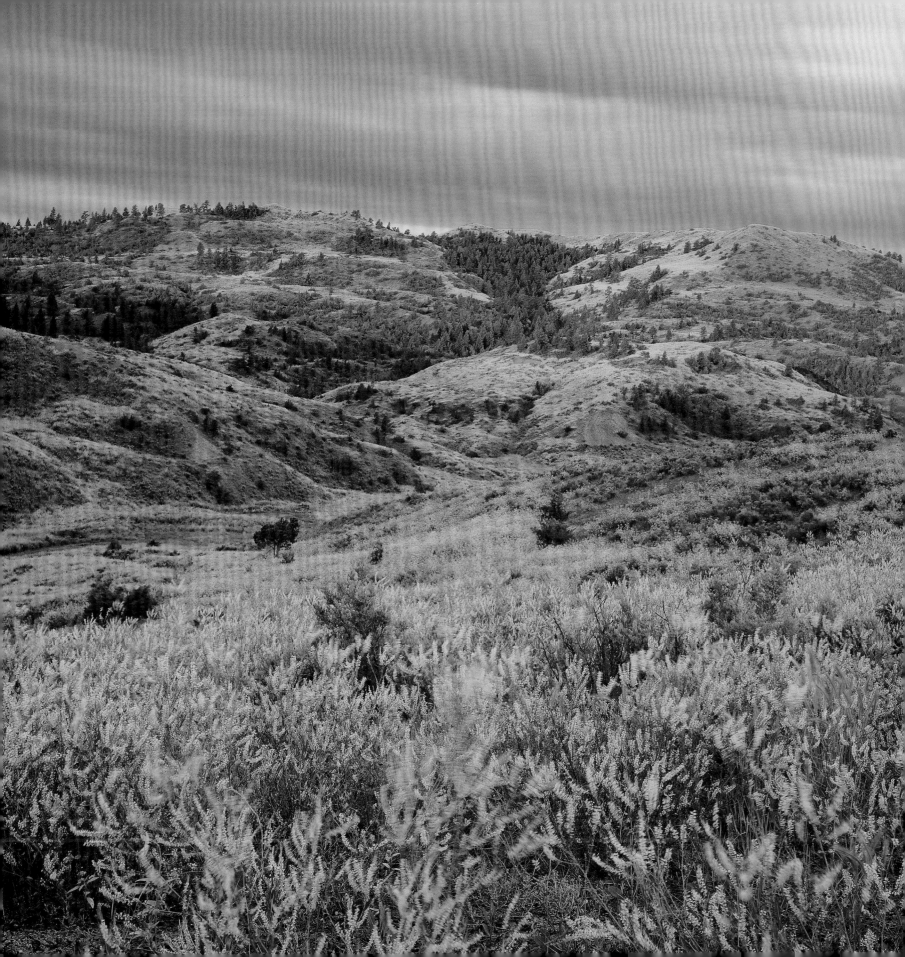

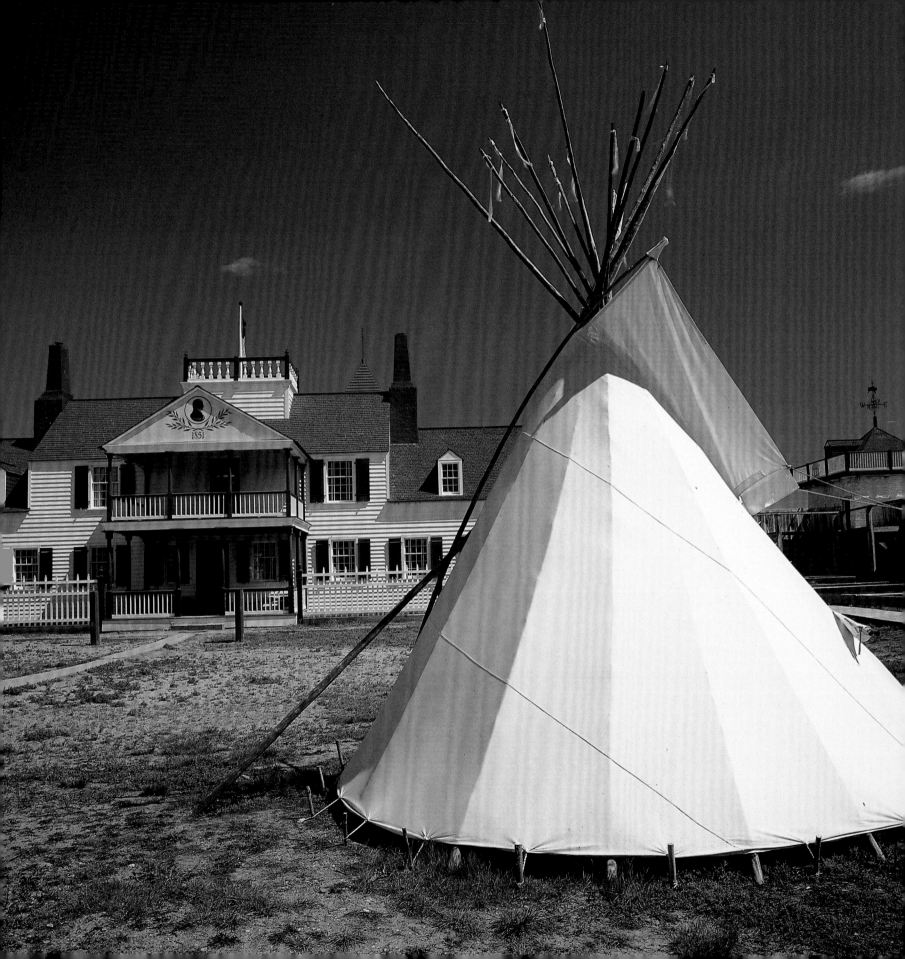

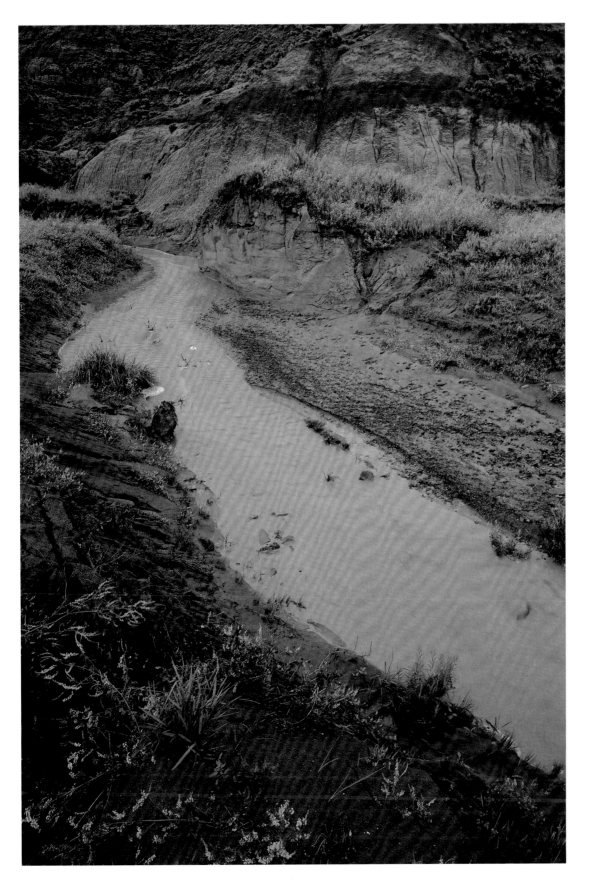

A small flash flood tumbles through Makoshika State Park, named "the bad lands" in the language of the Sioux people. This was once the domain of the dinosaurs, and scientists have found evidence of more than 10 species, including the skull of a triceratops.

FACING PAGE –
Fort Union, on the Montana-North Dakota border, has welcomed river-boat passengers, fur traders, and pioneers since 1829. The trading post is now a National Historic Site.

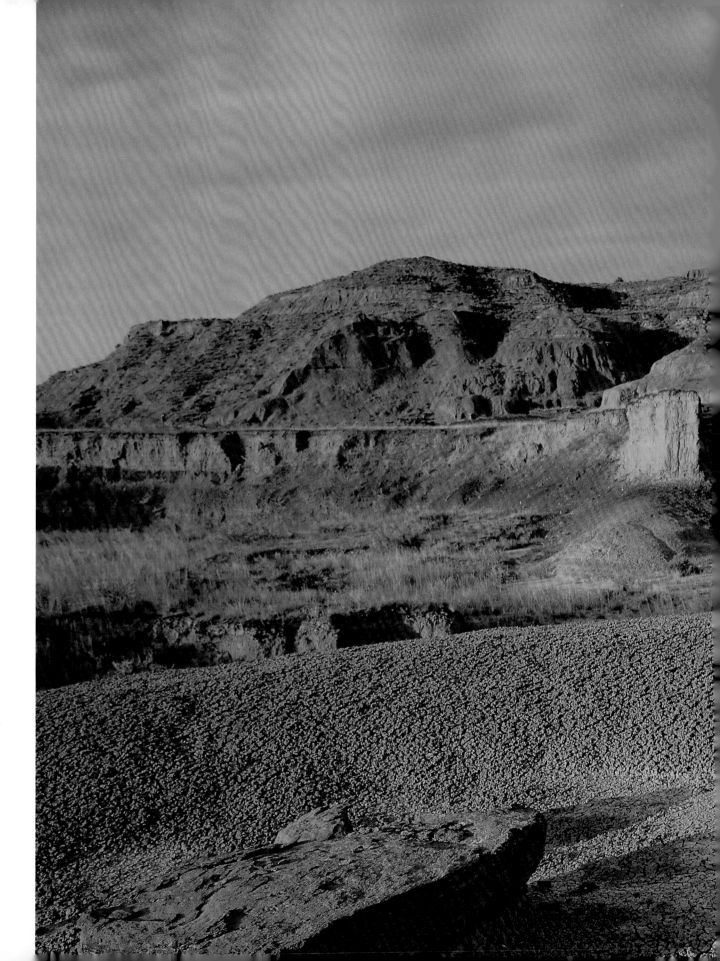

The landscape of Makoshika State Park is constantly changing, sculpted by meltwater, rain, and wind. Coyotes and bobcats hunt in the sagebrush and grasslands, while turkey vultures, falcons, and eagles circle above.

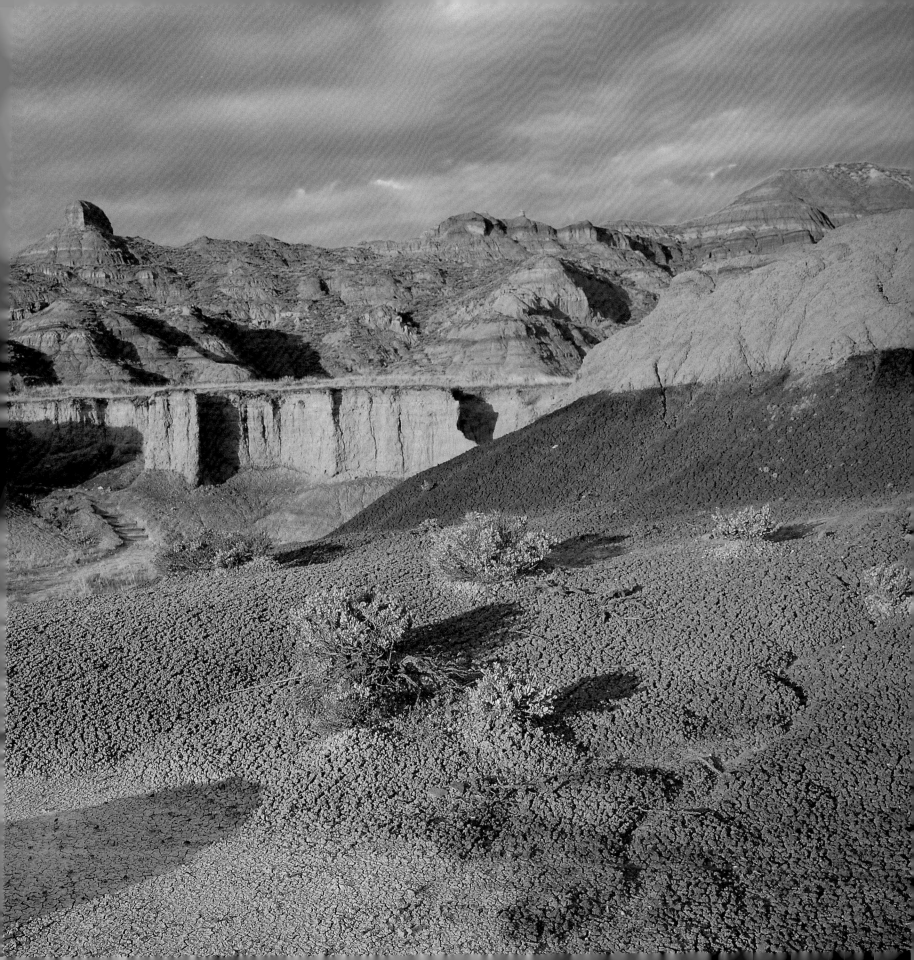

Photo Credits